Ornella Casazza

MASACCIO
and the Brancacci Chapel

SCALA/RIVERSIDE

CONTENTS

The San Giovenale Triptych 4

The Sagra 7

The Madonna and Child
 with St Anne 10

The Brancacci Chapel 12

The Pisa Polyptych 60

The Agony in the Garden 68

The Madonna and Child 69

The Story of St Julian 70

The Trinity 70

The Berlin Tondo 74

The Santa Maria Maggiore
 Polyptych 76

Bibliography 78

Index of Illustrations 80

© Copyright 1990 by SCALA, Istituto Fotografico
Editoriale S.p.A., Antella (Firenze)
Layout: Daniele Casalino
Photographs: Antonio Quattrone (by courtesy of the
Olivetti S.p.A.), cover and back cover, 10, 11, 13, 15,
16, 18, 19, 21, 26-50, 52-61; SCALA, 2-9, 12, 14,
17, 20, 22-25, 51, 63, 71, 74-77, 80; National Gallery,
London, 62, 81; Gemäldegalerie, Berlin-Dahlem, 64-70,
78, 79, 82; Paul Getty Museum, Malibu, 72; Lindenau
Museum, Aitenburg, 73
Produced by SCALA
Printed in Italy by: Amilcare Pizzi S.p.A.-arti grafiche
Cinisello Balsamo (Milan), 1997

*1. Adoration of the Magi, detail
Berlin-Dahlem, Gemäldegalerie*

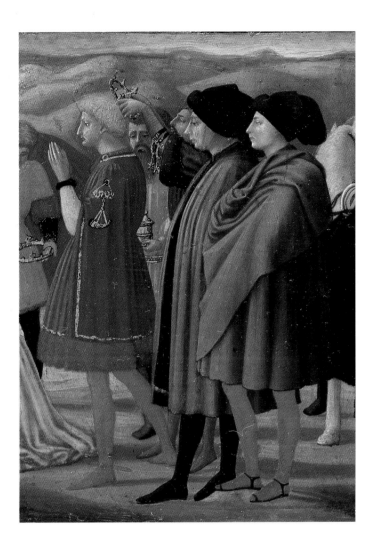

"…He was a very absent-minded and careless person, like one who has concentrated all his heart and will on art alone, and thinks little of himself or others. And he did not wish to concern himself with worldly matters, not even dress, and did not make a practice of recovering money from his debtors, except when in great need, instead of Thomas (which was his name), he was called Masaccio (clumsy Thomas) by everybody: not because he was a person of bad habits, being naturally good, but because of his extreme carelessness; in spite of this he was very affectionate and rendered services and favours to others, so that none could wish for more." This was written by Vasari in the Life of Masaccio.

He was born on December 21st 1401 at San Giovanni Valdarno and soon moved to Florence (1417) where he was already known as a painter in 1419.

In 1421 his brother, nicknamed Lo Scheggia, was in the modern and flourishing workshop of Bicci di Lorenzo in Florence, where Masaccio is also believed to have worked. His sister married the painter Mariotto di Cristofano, who was also from San Giovanni Valdarno but lived in Florence. Here too was Masolino, another native of the Valdarno transferred to Florence, where he was highly esteemed chiefly by the Florentine aristocracy and artistic circles: he was already back from a trip to Hungary (Procacci) where he had gone with Pippo Spano. In the Bremen *Madonna* of 1423 he is as up-to-date and refined as Gentile da Fabriano and has captured something of the best spirit of the early Ghiberti (Berti) whom he had helped with the north door of the Baptistry.

Although acting within the complicated late Gothic representation which was not in contrast with the classicist innovations, Masaccio was above all involved in the humanistic avant-garde of Brunelleschi and Donatello.

The tendency of both to exalt human value in every way and to restore dignity to the vulgar tongue is already evident in his first known painting: the *San Giovenale Triptych*, dated 23rd April 1422.

2

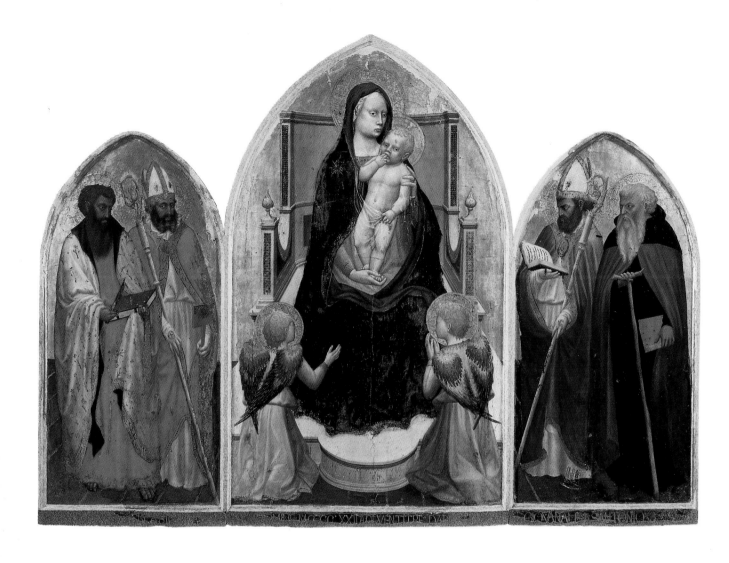

The San Giovenale Triptych

This shows the Madonna and Child enthroned in the central panel and four saints, two on each side panel. St Bartholomew and St Blaise on the left and St Ambrose and St Giovenale on the right.

In 1961 this work, which was discovered by Luciano Berti in the little church of San Giovenale, was shown at an exhibition of "Ancient Sacred Art" and attributed to Masaccio. Immediately afterwards Berti announced it to be the first original work by Masaccio because of its strong similiarities with the figures in the *Madonna and Child with St Anne* in the Uffizi, the *Madonna* of the Pisa Polyptych and the Santa Maria Maggiore Polyptych in Rome.

It is dated along the bottom with the inscription in modern humanist letters, the first in Europe not in Gothic characters: ANNO DOMINI MCCCCXXII A DI VENTITRE D'AP(PRILE). This inscription appeared during restoration begun after the exhibition of 1961: the original frame had been tampered with and the letters covered up with

another piece of frame stuck on over them.

In 1890 Guido Carocci, who attributed the triptych to the Sienese school, revealed that the three panels had been rejoined. They had been previously meddled with and separated, thereby almost totally destroying the gilt frames and carvings. After restoration the triptych was shown at the "Metodo e Scienza" exhibition in 1982, where it again drew the attention of art critics, and is now in the church of San Pietro at Cascia di Reggello (Caneva 1988).

According to recent documentary research by Ivo Becattini the work could have been commissioned by the Florentine Vanni Castellani who had the patronage of the church of San Giovenale. His monogram composed of two linked croziers with two Vs

2,3. San Giovenale Triptych
108 x 65 cm (central panel)
Reggello (Florence), church of San Pietro at Cascia

4

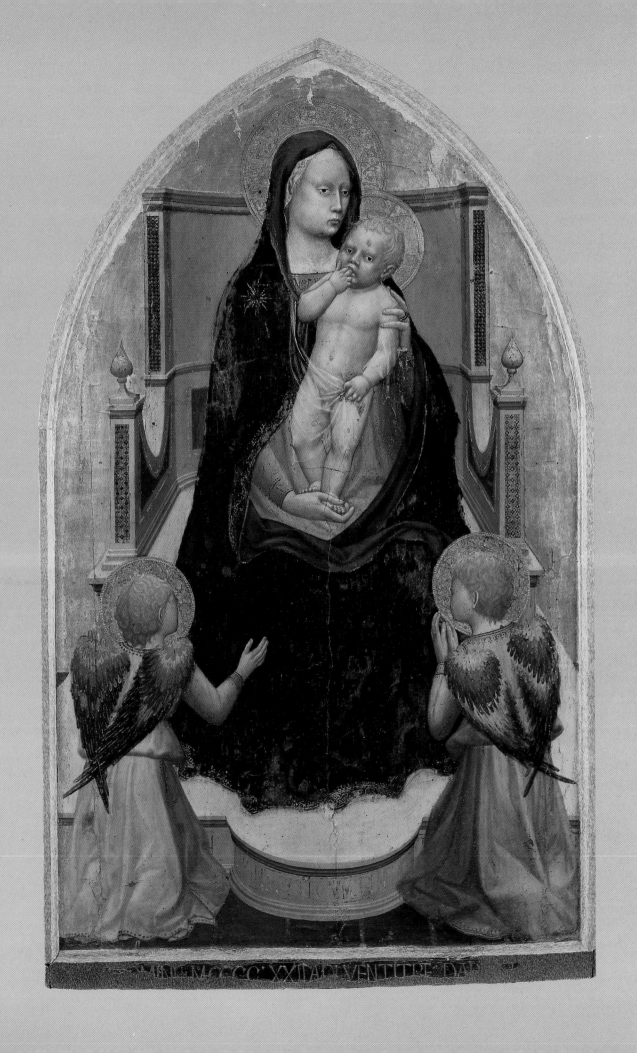

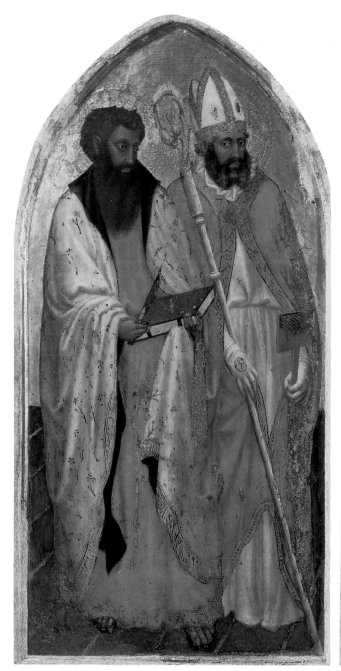
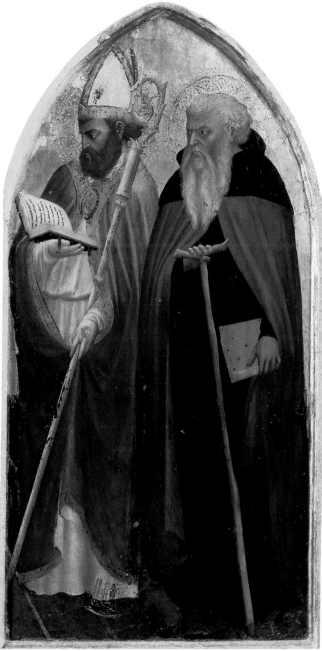

underneath is re-echoed in the painting by two saints' croziers, placed so as to form a space containing the Madonna, with the two Vs repeated in the angels' wings. In connection with this commission Becattini suggests that the triptych was painted in Florence and remained there for several years, since it does not appear until 1441 in the inventory of possessions of San Giovenale.

No mention of the triptych appears in any source, although Vasari refers to works by the young Masaccio in the area round San Giovanni Valdarno, yet it represents a milestone in early Renaissance painting. Already containing elements of innovation, the new treatment of perspective and new plasticity are in the spirit of the great Florentine contemporaries

Brunelleschi and Donatello (who was then working on the *St Louis* in the Museo dell'Opera di Santa Croce: the crozier is held in a "scissor grip" similar to San Giovenale). The spectator is drawn in among the characters by the space defined in the three panels: the two angels below the step with their backs to us and profiles disappearing, create intermediate space between the onlooker and the painting. They mark as it were the boundary beyond which the scene opens out. This device of arranging and articulating space is recurrent in Masaccio's style and one which he was to make use of again in the Brancacci Chapel. One example is the tax-collector with his back to us in the *Tribute Money*, on the extreme edge of the spatial dimension with the onlooker; another is the

6

episode of the *Distribution of Alms* where the child 53 seen from behind in its mother's arms marks an exact point between the characters of the scene and the observer. But it is to be found earlier than this, in the Pisa Polyptych, in the out-stretched figure of Mary Magdalene in the *Crucifixion* at the top and in the 63 executioner of the *Martyrdom of St Peter* in the 64 predella.

The Child, as in the central altarpiece of the Pisa 62 Polyptych (now in London), is sucking his fingers which taste of grapes. There is a definite allusion to the Eucharist although the gesture has its inspiration in ancient models and the child, in order to affirm its "naturalness," is naked like the classical putti.

When it first appeared critics were uncertain of the triptych's attribution to Masaccio. Now however it is generally agreed that he painted it and that it is the earliest known work by him. The unity of style which binds the whole work ideally and pictorially leads us to discard suggestions of collaboration on the side panels.

4,5. San Giovenale Triptych, side panels: St Bartholomew and St Blaise, St Ambrose and St Giovenale
88 x 44 cm
Reggello (Florence), church of San Pietro at Cascia

6. Donatello, St Louis
Florence, Museo dell'Opera di Santa Croce

The Sagra

Masaccio, who since January 7th 1422 had been enrolled in the Arte (Guild), took part in the great celebrations of April 19th of the same year for the consecration ceremony of the church of Santa Maria del Carmine with Brunelleschi, Donatello and Masolino. He had the job of immortalizing it in a fresco executed in chiaroscuro and terra verde "above the part towards the convent, in the cloister" with many figures: "five or six to a row.... decreasing...according to the line of vision.... and not all the same size, but with discernment, which distinguishes those who are short and fat from the tall and thin..."(Vasari).

Before this undertaking (which is dated by some around 1424), he probably made a trip to Rome for the Jubilee of 1423. This would explain his humanistic development: the Sagra procession could have reflected examples drawn from ancient reliefs. He certainly made a careful study of painting of the late Roman empire and early Christian era, as Vasari says, to "learn to be better than the others," and saw with his own eyes the ancient world and the historical-civil character of Imperial Roman art. It has been suggested that he was perhaps accompanied by Masolino, or even Donatello and Brunelleschi who, "never stopped working among the ruins of those buildings." The *Sagra* was destroyed at the end of the 16th century because of alterations to the convent and is now only partially recorded by drawings. One, by an anonymous Florentine of the second half of the 16th

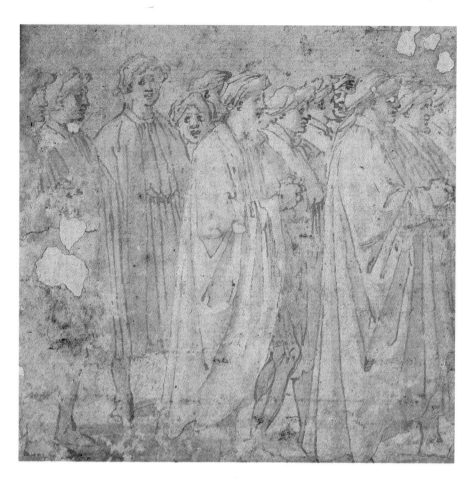

century published by Berti (1966), but in 1968 attributed to Commodi, is in the Procacci collection in Florence, while there are drawings in Folkestone, at the Albertina in Vienna, and in Florence at the Casa Buonarroti and the Prints and Drawings Rooms of the Uffizi. One other drawing in a private English collection, attributed to Federico Zuccari, has been recently published by Berti at the suggestion of Piero Pacini. Almost all the drawings refer to the same group of people, amongst whom several of those already mentioned by Vasari are recognisable.

Vasari wrote that "he painted the portraits of a great number of the citizens in cloaks and hoods following the procession: among these were Filippo di Ser Brunellesco in clogs, Donatello, Masolino da Panicale, who had been his master..." Besides these, Vasari noted the presence of a Brancacci, Niccolò da Uzzano, Giovanni di Bicci de' Medici, Bartolomeo Valori, Lorenzo Ridolfi and even "the doorkeeper with the keys in his hand."

The *Sagra* is the origin of Masaccio's portrait painting, as Vasari clearly indicates. The information is in the 1568 edition of the Lives, at which time there were still to be seen in Simone Corsi's house the portraits of Brunelleschi, Donatello, Masolino, Felice Brancacci, Niccolò da Uzzano, Giovanni di Bicci de'

Medici and Bartolomeo Valori, painted by Masaccio on panels taking the likenesses from the *Sagra*: in profile, in "cloaks and hoods" and half-length. This is a direct study of human reality, a glorified testimony to the succession of ancient and modern events; the same subtle and accurate reality which will later be found in the numerous contemporary portraits on the walls of the Brancacci Chapel.

Three of the portraits mentioned by Vasari — which would not have been the only ones — were grouped together by art historians: the portraits of a young man now in the Gardner Museum in Boston, in the Musée des Beaux Arts of Chambery and in the National Gallery of Washington. Most critics now agree that the last two are not by Masaccio because of their inferior quality and certain characteristics which suggest a later date or at most copies of works by him. Berenson's attribution of the Boston portrait to Masaccio was accepted by Salmi, Giglioli, Langton Douglas, Mesnil, Ragghianti, Laclotte, Hatfield and now by Berti, who agrees with Ragghianti that it is a portrait of Leon Battista Alberti. It should be dated between 1423 and 1425, that is earlier than the portrait of Alberti in the Brancacci Chapel in the episode of *St Peter Enthroned.*

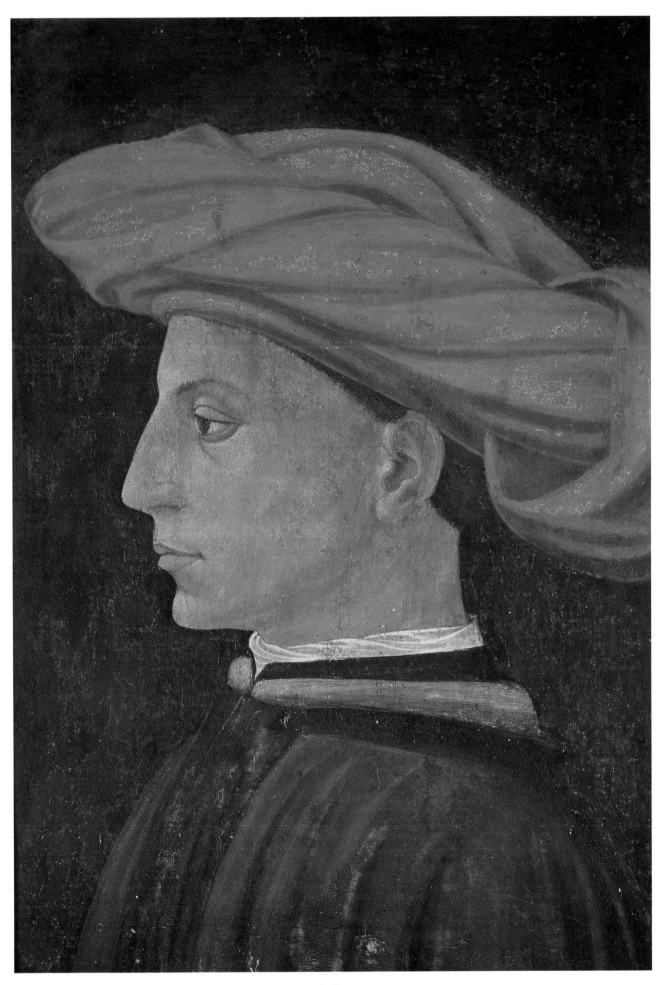

The Madonna and Child with St Anne

In 1424 Masaccio was again in Florence enrolled in the Compagnia di San Luca. Critics date the beginning of his collaboration with Masolino, visible in the *Madonna and Child with St Anne*, a panel for the church of Sant'Ambrogio now in the Uffizi, from this year, the same in which Masolino finished working in the church of Santo Stefano in Empoli. It is the first work in which the association of the two painters, which continued on the scaffolding of the Brancacci Chapel and then in Rome until Masaccio's death, is evident.

Vasari mentions this painting in the second edition of the Lives (1568), but attributes it entirely to Masaccio, indicating where it was placed "in the chapel next to the door which leads to the nuns' parlour."

The painting was first in the church of Sant'Ambrogio in Florence, then in the Galleria dell'Accademia, and then in 1919 it went to the Uffizi where it remains today.

At first art critics assumed the work to be entirely by Masaccio, following Vasari's opinion, but it soon became clear that it was the work of more than one artist. Masselli in 1832 and Cavalcaselle in 1864 were the first to notice affinities with Masolino's style.

D'Ancona in 1903 was the first to make out two distinct hands in the painting, separating the "graceful and delicate parts" (the faces of the Madonna and angels) from the "full and rather coarse forms" (the Child and St Anne). However it was Roberto Longhi in 1940 who tackled the problem of the collaboration between Masaccio and Masolino, attributing the Madonna and Child and the angel holding the curtain at the right to Masaccio and the rest to Masolino. Masaccio is thus considered the independent collaborator of Masolino, who perhaps had been commissioned to paint the panel. Ragghianti subsequently assigned to Masaccio the foreshortened angel at the top holding the curtain. Salmi (1948) and Salvini (1952) considered St Anne to be by Masaccio mostly because of "the hand exploring the depth of the picture" in a daringly foreshortened position above the head of the Child, which Procacci too (1980) thought to be Masaccio's invention. But in Berti's opinion these spatial innovations belong to Masolino and are related to the "similarly extended" hand of Christ in the *Adoration of the Magi* by Gentile da Fabriano, 1423, in the Uffizi.

As far as dating the work is concerned, scholars all agree that it was executed in Masaccio's earliest period. Before the discovery of the *San Giovenale Triptych* dates varied between 1420 and 1425 and have since been put beyond 1422. Because of the tendency to make the date coincide with the presumed period of collaboration between the two artists the preference is for sometime between 1424 (November) and 1425 (September) when Masolino had several commitments to fulfil. As in the *San Giovenale Triptych*, the writing in capital letters "AVE MARIA...," is again present, while in St Anne's halo another inscription in Italian can be read, interpreted by Longhi: "SANT'ANNA È DI NOSTRA DONNA FAST(IGIO)."

The space is articulated in parallel planes, as in the spatial composition of some of the Brancacci Chapel episodes: the Madonna's knees on the first plane, the Child clasped by his mother's hands on the second, then the Madonna's body, the throne and the angels, St Anne, the curtain and the other angels and lastly the gold background.

The composition with St Anne placed third in respect of the Virgin and Child, is coherent in its entirety and the figures achieve a sculptural massiveness. The presence of St Anne has been interpreted with a particular meaning (Verdon, 1988): the rule of filial obedience of the Benedectine nuns towards the Mother Superior.

It is in the Brancacci Chapel that the collaboration between Masaccio and Masolino increases and becomes habitual. Here they painted the stories of St Peter commissioned by Felice Brancacci. Although no clear documents exist on hiring or contracts of any kind, it is assumed that the two received the commission together. It would be otherwise inexplicable why Masaccio was obliged to paint a St Paul as a test to set beside Masolino's St Peter, praised by the patrons of the chapel.

9. *Madonna and Child with St Anne*
175 x 103 cm
Florence, Uffizi

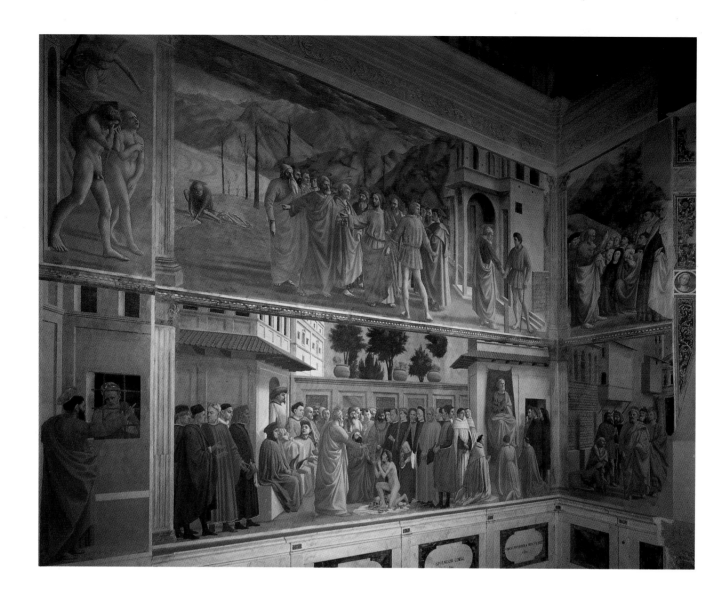

The Brancacci Chapel

The chapel in the righthand arm of the transept in the church of Santa Maria del Carmine is consecrated to the Madonna del Popolo, and a painting of the Virgin stands on the altar. The patrons of the chapel were the Brancacci family, from the second half of the 14th century until 1780, when it was taken over by the Riccardi family.

Felice, the son of Michele Brancacci, was the patron of the chapel from 1422 till at least 1436, as we learn from the testament that he drew up on 26 June of that year before he set off for Cairo, where he had been sent as Florentine Ambassador. Felice was a member of the Florentine ruling class and held a number of important public positions: as early as 1412 he was already one of the sixteen Gonfalonieri di Compagnia, and in 1418 he was one of the twelve Buonomini. Later he was nominated Ambassador to Lunigiana, before taking up his post in Cairo in 1422, together with Carlo Federighi, a man of letters,

described in the documents as a philosopher and an expert in legal matters. In 1426 Felice held the post of Commissario, or officer in charge, of the troops that besieged Brescia during the war against Milan. He also administered his own profitable silk trading company, and in 1433 he married Lena, the daughter of Palla Strozzi. Felice was a rich and powerful man and he commissioned the fresco decoration of the chapel shortly after he returned from Cairo in 1423. Berti has in fact suggested that work on the frescoes began in 1424, at a time when Masaccio and Masolino were working together, and that it continued until 1427 or 1428, when Masaccio set off for Rome, leaving the fresco cycle unfinished.

The appearance of the chapel today is the result of the alterations begun immediately after Felice Brancacci fell out of favour: he was exiled in 1435 and declared a rebel in 1458. Further changes were carried out in the 18th and 19th centuries.

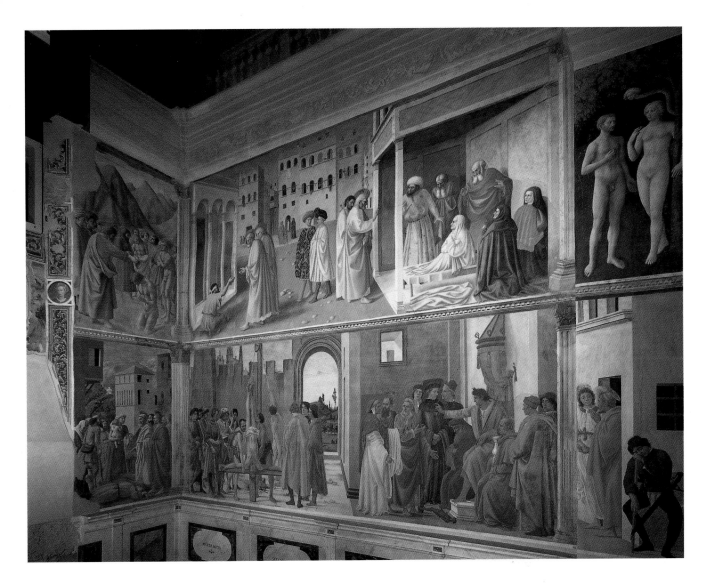

10,11. Stories from the Life of St Peter
Florence, Brancacci Chapel

Originally the chapel was cross-vaulted and lit by a very tall and narrow two-light window; the last of the stories from the life of St Peter, his *Crucifixion*, was probably painted on the wall below the window, but this fresco was destroyed soon after Brancacci was declared a rebel so as to cancel all traces of a patron who had become politically embarrassing. The chapel, formerly the chapel of St Peter, was reconsecrated to the Madonna del Popolo and an ancient painting of the Virgin was hung on the wall, above the altar. This painting, recently restored, has now been attributed to Coppo di Marcovaldo (Paolucci).

It appears that Felice Brancacci was subjected to an operation of *damnatio memoriae*, for all the portrayals of people connected to the Brancacci family 46 were eliminated from Masaccio's fresco of the *Raising of the Son of Theophilus*. The scene was then restored in 1481-82 by Filippino Lippi, who also completed the cycle.

After the chapel was reconsecrated to the Virgin a number of votive lamps were installed: the lamp-black they produced coated the surface of the frescoes, causing such damage that as early as the second half of the 16th century they had to be cleaned.

In 1670 further alterations were carried out: the two levels of frescoes were divided by four sculptures set in carved and gilded wooden frames. A short while later, in 1674, the chapel was furnished with marble balustrades and the floor and steps leading up to the altar were rebuilt.

It was probably at this time that the leaves were added to conceal the nudity of Adam and Eve in the two frescoes, Masolino's *Temptation* and Masaccio's 40 *Expulsion from the Garden of Eden*. In fact, we know 41 that they had not yet been added in 1652, and they were probably conceived as a sort of censorship operation during the reign of the notoriously bigoted Cosimo III.

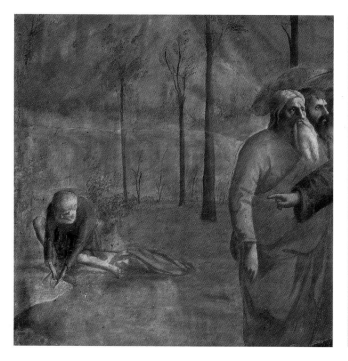
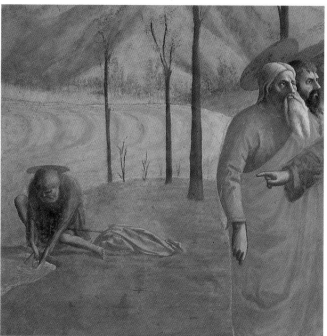

12,13. Details of the Tribute Money, before and after restoration Florence, Brancacci Chapel

In 1680 Marquis Francesco Ferroni, interpreting the aesthetic taste of the time which considered "those ugly figures dressed in long flowing coats and wide mantles" quite unseemly, offered to buy the chapel and to get rid of the frescoes. He suggested that the chapel should be entirely renovated and made more like the Corsini Chapel, in the other arm of the transept. Fortunately, Grand Duchess Vittoria della Rovere stepped in and prevented the destruction of the frescoes: Marquis Ferroni's alternative plan, "to have the wall sawed off so as to preserve the most precious paintings elsewhere," thus renovating the chapel without causing severe damage to the frescoes, was also vetoed by the Grand Duchess.

In 1734 the painter Antonio Pillori cleaned the frescoes at the same time as the whole church was undergoing an operation of redecoration. But the most detrimental alterations in the chapel were carried out in 1746-48. Because of the dangerous infiltrations of damp reported by Richa, the cross vault was demolished entirely, and with it the ceiling frescoes of the Evangelists that had been painted by Masolino. The frescoes in the lunettes were also destroyed.

Vincenzo Meucci redecorated the ceiling, painting the scene of the Madonna giving the scapular to St Simon Stock, while Carlo Sacconi painted a series of architectural motifs in the side lunettes. And the "beautifully wrought and finely decorated window" was also added.

During the surveys carried out during the recent restoration programme nothing was found underneath the decorations in the lunettes, whereas under the frescoes on the end wall, on either side of the window, the restorers found two 15th-century sinopias of scenes from the St Peter cycle by Masaccio and Masolino.

And so we come to the terrible fire that ravaged the church, on the night between 28 and 29 January 1771: luckily it did not cause any irreparable damage to the chapel. The wooden frames that separated the two tiers of frescoes caught fire, and the heat from the flames altered the colours in that area; also, some pieces of *intonaco*, or plaster, fell off from the steps behind the tax collector in the *Tribute Money* 29 and from the loggia behind the cripple in the *Raising* 37 *of Tabitha.*

The fire did not damage the painting of the Madonna del Popolo which had been removed to the monastery the previous year.

In 1780 Marquis Gabriello Riccardi became the new patron of the chapel; after having it restored, he opened it to the public. The conditions of the chapel were carefully monitored throughout the 19th century: redecorations were carried out, and all signs of damage caused by humidity, by the lampblack from the candles, and by wax splashing onto the frescoes were reported and studied, until the decision to intervene again was taken.

In October 1904 the decision was taken to clean the frescoes again, under the supervision of expert restorer Filippo Fiscali. But on this occasion the restoration did little more than

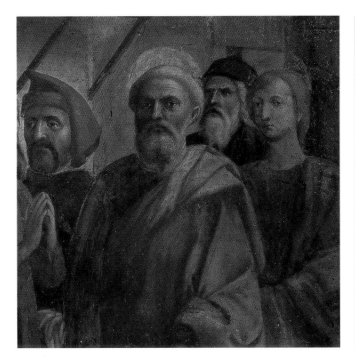

14,15. Details of St Peter Healing the Sick with his Shadow, before and after restoration
Florence, Brancacci Chapel

remove the dust from the surface of the frescoes.

Under the supervision of Ugo Procacci two small slabs of marble, placed on the same level as the altar's tympanum, were removed, revealing two sections of painted wall surface; the colour tonality of these two small sections is evidence of what the frescoes must have looked like before the 1771 fire. Fifty years after this unique discovery, an accurate survey and investigation of all the painted surfaces was carried out, as background research to the recent restoration project.

On either side of the Baroque window and beneath the 18th-century *intonaco* two sinopias were found: they were the preparatory sketches for the scenes destroyed during the modernizations carried out in 1746-48. One depicts St Peter in despair after his denial of Christ, while the other shows Christ nominating Peter his universal shepherd with the words "*pasce agnos meos, pasce oves meas.*"

The striking differences between the two scenes enable us to attribute one to Masaccio and the other to Masolino: this also reinforces the theory that the two artists were working together on the fresco cycle from the very beginning, conceiving and planning the scenes together, so that the stories illustrated by one were perfectly in harmony with those painted by the other.

The discovery of these two sinopias has filled some of the gaps in the documentation, as well as allowing us now a complete reconstruction of the stories from the life of Peter, preceded by the portrayals of

Adam and Eve and the Evangelists. The overall programme is a *historia salutis*, that is a history of the salvation of mankind through Christ, mediated by the Church, represented by Peter.

Another important part of the restoration procedure was the dismantling of the marble altar. This revealed surviving fragments of decoration in the jambs of the original two-light window: two medallions containing heads, again one by Masaccio and the other by Masolino, as well as foliage motifs. These ornamental details are perfectly preserved and therefore of great interest, for they give us an excellent indication of what the original colour tonality of the frescoes must have been like.

Equally important was the rediscovery of further fragments of a scene that Masaccio had painted on the wall above the altar: they were probably part of a *Crucifixion of St Peter*, the final episode in the *mysterium salutis*, man's salvation through Christ and the Church. Starting from the two frescoes in the upper section, to the right and the left, we have the facts leading up to the events in the story, as recounted in the Acts of the Apostles and the Golden Legend. The two episodes depict the end of man's harmony with God, and since this is occasioned by man, the move towards reconciliation can only come from God, through His Word, as witnessed and communicated by the Evangelists, who were portrayed on the ceiling. And then, of course, came the stories from the life of St Peter, beginning in the left lunette, above the *Tribute Money*, with the scene of *Peter's*

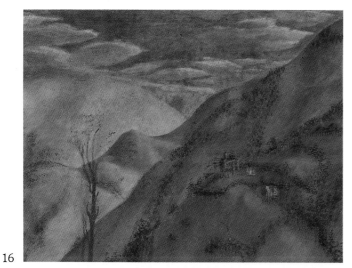

16

17

16. *Tribute Money, detail*
Florence, Brancacci Chapel

17. *Paolo Uccello, Battle of San Romano, detail*
Florence, Uffizi

18,19. *Healing of the Cripple and Tribute Money, details*
Florence, Brancacci Chapel

20. *Donatello, St George, detail of the predella*
Florence, Bargello Museum

Calling; the stories continued on the opposite wall with the scene of the shipwreck, from which one can be saved only through faith in Christ. Next come the frescoes on either side of the window: the scene showing Peter repenting, which marks the beginning of salvation, and Peter being nominated representative of Christ's Church on earth and universal shepherd of souls (the sinopias of these last two scenes were the ones rediscovered beneath the 18th-century additions and Baldini has attributed the former to Masaccio and the latter to Masolino). The story
28 continues with the scene of the *Tribute Money*, where the entire idea of salvation is placed in a context of
37 historical reality; the *Healing of the Cripple and the Raising of Tabitha*, symbolizing the life-giving power
34 that emanates from Christ the Lord; *St Peter Preaching*, which is the announcement of mankind's salva-
35 tion and the promise coming true; the *Baptism of the Neophytes*, signifying the Church's power to forgive man's sins through baptism in the name of Jesus Christ. The story continues on the level below with
50 *St Peter Healing the Sick with his Shadow*, symboliz-ing salvation granted by the Church through Peter;

the *Distribution of Alms*, an indictment of those who 53 sin against the sanctity of the Christian way of life for love of money or out of treachery; the *Raising of the* 46 *Son of Theophilus*, preceded by *St Paul Visiting St* 44 *Peter in Prison*, states once again that the True Word will save mankind and perform miracles; Peter and Paul's *Disputation with Simon Magus*, preceded by 56 *Peter Being Freed from Prison*, teaches us that there 59 is no connection between magical practices and the signs of salvation; and lastly the *Crucifixion* is the sub- 54 limation and the essential moment of man's reunion with Christ.

Although not underestimating the importance of the theological message, critics and scholars have also pointed out the relationship between the stories and the patron who had commissioned the frescoes, a seafarer, a sailor-fisherman, like Peter (in the Call-ing): like Peter praying for God's help during the storm (in the scene of the Shipwreck), and Felice Brancacci must certainly have been caught in storms during his travels as a merchant or as an ambassador. Nor should we forget the fact that Brancacci had his name included in the Catasto, accepting his duty to pay taxes to the city (*Tribute Money*).

Let us now see how the two artists divided up their work. Masolino is entirely responsible for the *Rais-* 37 *ing of Tabitha and the Healing of the Cripple* and for the fresco of the *Temptation*, while Masaccio 40 painted the *Baptism of the Neophytes* on the wall 35 space to the right of the window. On the other side, the lefthand side, Masaccio painted the *Expulsion* 21 *from the Garden of Eden* and the *Tribute Money*, 28 whereas Masolino painted the fresco to the left of the window, *St Peter Preaching*. 34

If we repeat this alternating pattern, with the ar-tists dividing up the wall space equally, we can specu-late how they must have worked on the upper level as well, on the frescoes in the lunettes that were des-troyed during the 18th century. Assuming, as we

18

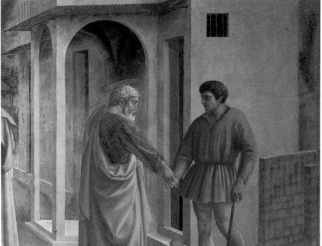

19

20

have shown, that the two painters began working on the chapel's frescoes together, there would have been an equal division of labour on this level as well: this would explain not only the terms of their collaboration, but the fact that the two artists obviously were working from a single project they had probably drawn up together.

The division of spaces and episodes between the two would have given the chapel a perfect internal unity: the two artistic styles, thus presented in alternation, would not have created any glaring contrasts. The pattern of alternating styles would have been noticeable not only in the horizontal arrangement of the scenes, but also vertically. This would have conveyed a remarkable feeling of order and harmony.

This method of division of labour avoided the problem of having a whole wall painted by Masaccio standing opposite the other one, entirely painted by Masolino, in obvious juxtaposition; both groups of paintings are fully integrated and balanced in the overall design. It will be enough to mention the two most famous scenes: the *Tribute Money* and the *Raising of Tabitha*. Although the two scenes are conceived in a very different manner, in both frescoes the main characters are set on stages that share the same perspective and that were obviously planned at the same time. Another important unifying element is provided by the fluted pilaster strips at the edge of the scenes and in the corners where the side walls meet the end wall: they are elements of architecture within the architecture and open up the spaces and the different planes on which the characters are placed.

But this project for a perfectly equal division of labour and space was never completed. After the upper level was finished, and when the time had come to start work on the lower one, Masolino abandoned the project; and not long afterwards Masaccio himself left Florence for Rome, to join Masolino

28
37

who had just returned from Hungary (1427).

Another dominant architectural element is the depiction of the city: although none of the buildings are exact reproductions of existing constructions, the general mood of the city is recreated. The scenes are set in an urban reality reminiscent of Florence, and this gives the stories great credibility, suggesting that the events did not take place "once upon a time" in a distant past, but in a world which is a mirror image of our present-day surroundings.

The *Healing of the Cripple and the Raising of Tabitha* takes place in a setting that looks very much like a Florentine square. And the architectural background in the other frescoes, both Masolino's and Masaccio's, also share this mixture of ancient and contemporary buildings: in the *Distribution of Alms*, for example, the bell tower on the right has two-light mullioned windows just like those of Santa Maria Novella; the tower house in the background looks like the castles which will later be known as Medici castles, similar in size and shape to Palazzo Vecchio; the foreshortened building which divides the space in the middle is clearly reminiscent of Brunelleschi's constructions.

37

53

In the scene of *St Peter Healing the Sick with his Shadow* the street, shown in perspective, is flanked by typically Florentine mediaeval houses and a splendid palace in rusticated stone, the lower part of which looks like Palazzo Vecchio, while the upper section is reminiscent of Palazzo Pitti. And the house of the tax collector in the *Tribute Money* is also modelled on early Renaissance buildings: it bears a resemblance to the palace in the predella of Donatello's *St George*, but it also exhibits an entirely new approach towards perspective, reminiscent of Brunelleschi's Loggia degli Innocenti (and the roundels are clearly modelled on that construction).

Even Filippino, in his *Crucifixion of St Peter*, includes contemporary characters witnessing the event, as well as realistic architectural constructions, some of which are loosely modelled on real buildings, while others are exact portrayals. But it would have been difficult to place the protagonists of the story in these contemporary Florentine settings without creating a contrast, without them losing their credibility. So the artist has added an almost exact reproduction of sections of ancient Rome, with the old walls, the landscape beyond the city gates, the city above the walls: a portrayal of a city done in the manner of the Northern painters who were just beginning to become well-known in Italy. But Filippino could not avoid adding a detail that is uniquely Florentine: the roof of the Baptistry.

Other elements of visible and recognizable contemporary life can be found in the landscape backgrounds, in the characters' gestures and actions: notice, for example, in the *Tribute Money*, Peter catching the fish and the detailed description of his rod with its fishing line made of twine, or the presence of people dressed in Quattrocento costumes amidst the Apostles wearing Roman togas, or the countryside divided into small plots where different crops are cultivated (this detail we shall find again in paintings by Domenico Veneziano and Paolo Uccello); the flowing river in the *Baptism of the Neophytes*, the drops of water on the neophyte's head, splashing off and into the river; the shadows of the bodies invested by rays of light; the stubble on the face of one of the onlookers, the ear of another folded over by his turban; the shadow projected onto the wall by one of the characters in the *St Peter Enthroned*, the man undressing, and, of course, the trembling nude in the *Baptism*.

In all the episodes the main character is always St Peter, shown as he performs the actions described in the Scriptures. His portrayal was based on an iconography that remained fairly constant in Italian art, and of all the Apostles he is easily the most recognizable: a strong, middle-aged man, with grey, curly hair, slightly receding or tonsured. He wears a yellow cloak over a blue tunic. Masaccio and Masolino, and later Filippino, follow this physical model exactly in all the scenes, although the actual facial features vary slightly, for each artist elaborated his own Peter.

Masaccio painted Peter's face with wide expanses of colour, depicting his hair as flowing and wavy in the early scenes (the ones on the upper level); while he portrays him with a tonsure in the later episodes from his life, the ones on the lower level (for, according to tradition, it was Peter who introduced the practice). On a foundation of *terra verde*, which frequently resurfaces through the skin colour, Masaccio portrays St Peter in the following ways in the *Tribute Money*: on the right, together with the tax collector, he is shown in profile, his face consisting of broad patches of colour, and his hair dishevelled; in the centre, as he listens to Christ's instructions, his face is more carefully executed and his position is almost frontal, so that he conveys an impression of gravity: he could almost be an ancient philosopher, Plato perhaps. He is clearly a thinker, a mature man: his hair is nearly white, and even his eyebrows have some white in them.

In the *Baptism of the Neophytes*, his powerful neck is lit from behind by the stream of sunlight coming in from the chapel's window. His profile, in the half-shadow, has a strongly sculptural effect.

In the scene of the *Raising of the Son of Theophilus*, where Peter performs the miracle, his hair is different: here he displays the tonsure which, as we mentioned, was a practice apparently introduced by him. According to the traditional account, when he was in Antioch preaching the Christian faith, the heathen rulers ordered that his hair be shaved at the top of his head as a punishment and a sign of contempt. In all the later episodes Masaccio portrays him with the triple tonsure, consisting of three concentric circles, which in some ways resembles the conical headdress made up of three crowns, the tiara, worn by the Pope on the most solemn occasions. The papal tiara is also called the Triregnum, for the three crowns also symbolize the three powers of the head of the Church: imperial, regal and ecclesiastic. And this is how Peter is portrayed in the *St Peter Enthroned*, in *St Peter Healing the Sick with his Shadow*, and in the *Distribution of Alms*, where the tonsure is even more obvious because his head is shown in profile.

Masolino's St Peter is more controlled: his curly hair is portrayed in greater detail and the skin tone (and, as a result, his expression) is rendered with numerous tiny brushstrokes, creating shapes and

volumes with a sfumato technique, with gradual tonality changes.

Filippino, in his stories on the lower level recounting the last episodes from Peter's life on earth, portrays him simply as a mature man: a full head of white hair, with no tonsure, in the scenes of *St Paul Visiting Peter in Prison*, their *Disputation with Simon Magus* and the *Crucifixion*. Whereas in the scene of the *Angel Freeing St Peter from Prison*, he portrays him with the triple tonsure. 44 56 54 59

The Expulsion from the Garden of Eden

This fresco was cut at the top during the 18th-century architectural alterations (1746-48). By comparing the height of the fresco to the height of the *Tribute Money* next to it, we can see by how much it has been reduced, for the two scenes must have met in the corner, separated only by the painted pilaster strips (the same occurs below, at the join between *St Peter in Prison* and the *Raising of the Son of Theophilus*). This is one of the frescoes which has suffered the greatest damage, for the blue of the sky has been lost. This deterioration must have been noticeable already at the time of Cavalcaselle, for he wrote that the blue of the sky had lost a great deal of its original brilliance. But the blue that Cavalcaselle saw was not actually the original blue paint, but rather a dark monochrome substance which had been spread over the painting's surface after the fire. 28 44 46

The recent restoration removed that substance, but all that was found underneath it was the grey-blue primer that Masaccio applied *a fresco*, before then adding the azurite *a secco*, that is after the plaster had dried. The azurite layer, as in the case of Masolino's painting opposite, was already gone before the monochrome substance was added.

If we take the *giornata*, or day's work, that includes the figure of Adam, we see that the background colour is more intense; this might suggest a mistake in the application of the blue-grey colour for the sky (for example, that the colour applied on the following day did not match it perfectly). But that is not the case: it is simply evidence of the total loss of the original colour.

Accepted by scholars as entirely by Masaccio, this scene has been compared to Masolino's fresco of the *Temptation*: Masaccio's concrete and dramatic portrayal of the figures, his truly innovative Renaissance spirit, stand in striking contrast to Masolino's late Gothic scene, lacking in psychological depth. In Masaccio's painting, man, although a sinner, has not lost his dignity: he appears neither debased nor degraded, and the beauty of his body is a blend of classical 40

archetypes and innovative forms of expression.

As far as Eve is concerned, one cannot help thinking of earlier interpretations of the Graeco-Roman *Venus Pudica* in 14th-century examples, such as Giovanni Pisano's *Temperance* on the pulpit in Pisa Cathedral (incidentally, two of the damned on that same pulpit, holding their heads in their hands, were clearly the models that inspired the figure of Adam). Masaccio's Eve is also reminiscent of the one in the relief of the *Expulsion* on the fountain in Perugia, also by Pisano; nor can one deny the resemblance, especially in the expression of her mouth, with the Isaac on Brunelleschi's panel for the competition for the Baptistry Doors. But Masaccio's Eve is only similar to a *Venus Pudica* in her gesture, because her body expresses dramatically all the suffering in the world. Scholars have also pointed out the likely precedents for the figure of Adam: from classical models such as Laocoon and Marsyas, to more contemporary examples, such as Donatello's *Crucifix* in Santa Croce. 22 23 24 25

And yet, all these borrowings from classical and more recent art were then used by Masaccio in a very personal way, to build up a totally original end product which must have truly impressed his contemporaries. Think, for example, of the foreshortened angel, shown in flight, in the process of landing on a fiery cloud, as red as his robe. And add to this the importance that Masaccio attributed to his nudes (and this is an element that we can now judge properly since the recent restoration has removed the leaves added during the 17th century). By the use of the nude, Masaccio removes his characters from the sphere of everyday life and places them in an ideal world, but one which is depicted realistically. The nudity of the figures is no longer used simply to imply that the scene is taking place in a remote past, but rather to suggest a form of ethical idealization. And, in fact, the nudity of Adam and Eve can indicate both the innocence of the Garden of Eden (Masolino) and the transient nature of human beings (Masaccio). The two themes are frequently used side by side in the frescoes.

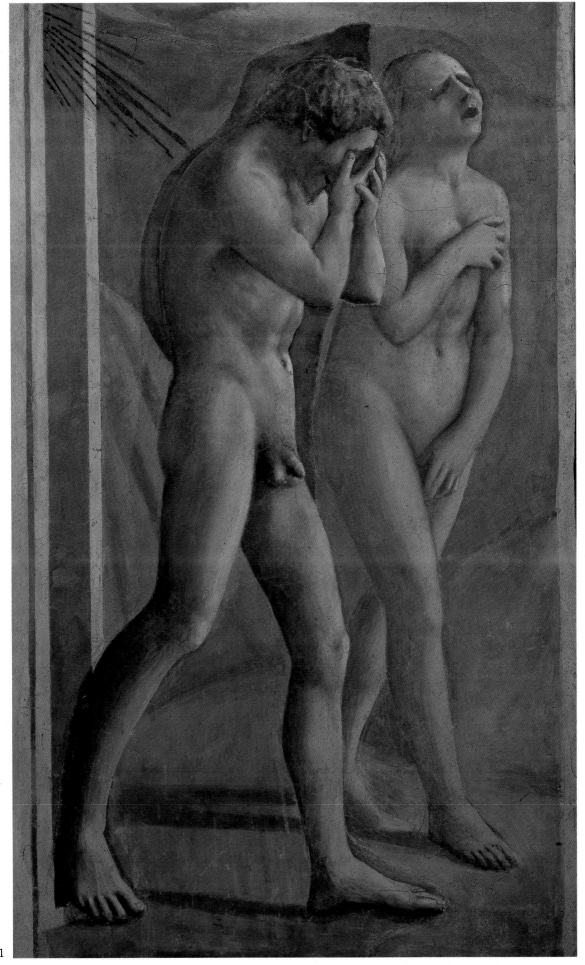

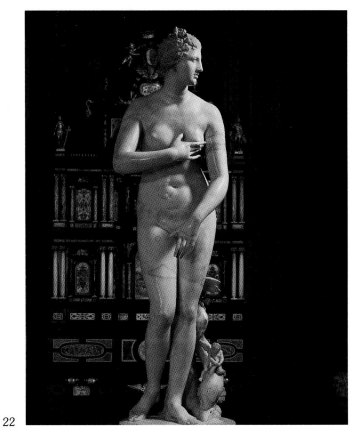

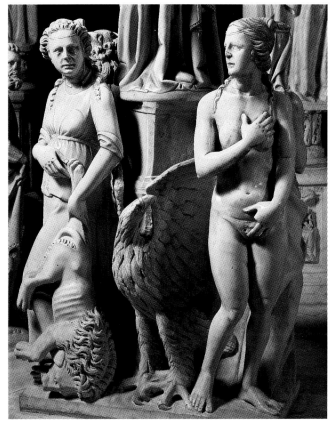

22

23

*21. Expulsion from the Garden of Eden
(Masaccio) 208 x 88 cm
Florence, Brancacci Chapel*

*22. Medici Venus
Florence, Uffizi*

*24. Marsyas
Vatican, Gregorian Profane Museum*

*23. Giovanni Pisano, Pulpit, detail
Pisa, Cathedral*

*25. Donatello, Crucifix
Florence, Santa Croce*

24

25

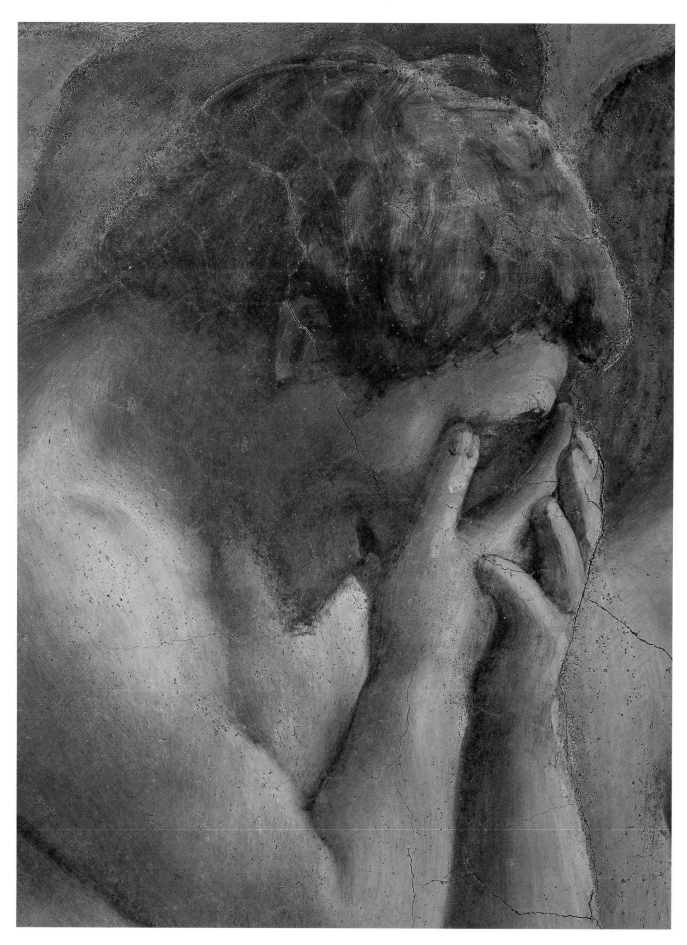

26,27. Expulsion from the Garden of Eden, details
Florence, Brancacci Chapel

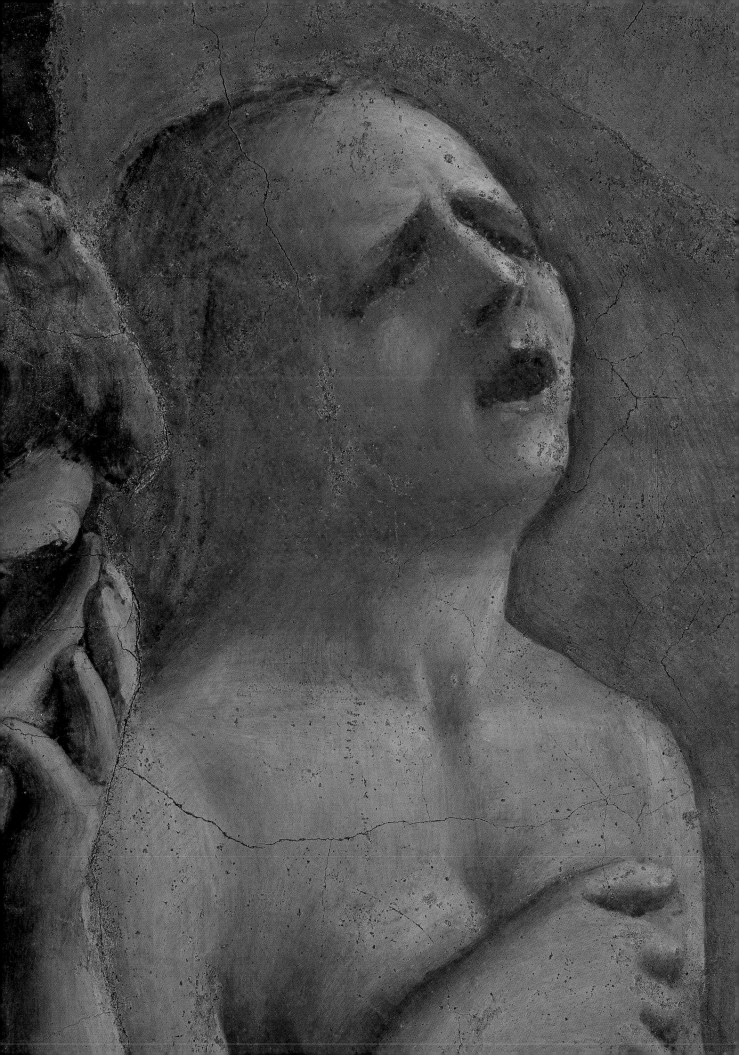

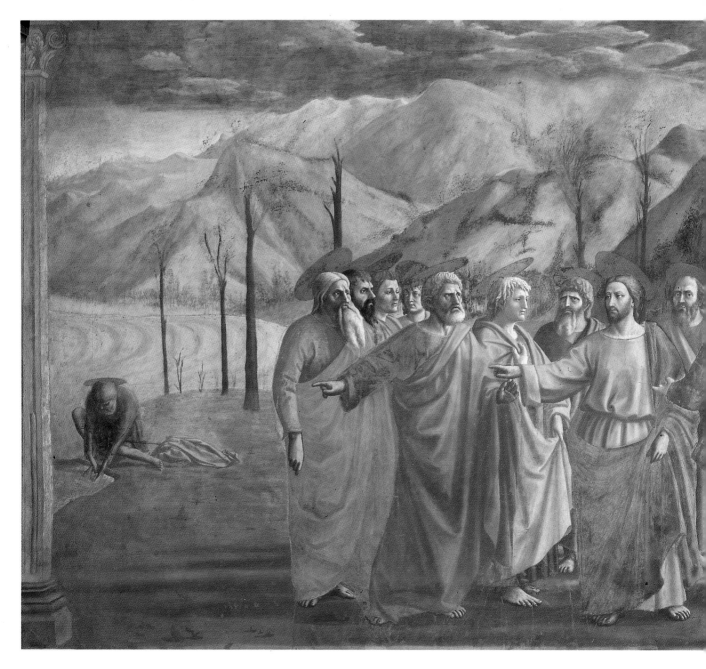

28. Tribute Money (Masaccio)
255 x 598 cm
Florence, Brancacci Chapel

From the tall and narrow opening of the gate to Paradise, steeped in deep shadows, bright rays of light stream out, symbolizing God's will expelling man after his sin: this command is repeated by the angel who indicates the way down to earth with his left hand. Outside Paradise, in a barren landscape, two small mounds of earth appear to accompany the movements of the two figures: the lefthand one, with its steeper slope, echoes the movement of Adam's left leg, while the other one, with its more rounded shape, matches Eve's left leg, and reinforces the idea that they are walking away, in a sense propelled by God's command.

The shadows, which have now been restored to their original strength, emphasize this difficult progression towards the trials and tribulations of life on earth. The event is one of extreme gravity, and no superficial or unnecessary actions are allowed: the overall dramatic intensity permeates everything, for everything is an expression of God's will. The rhythm of the two figures is further stressed by the movement of their arms and their heads: Adam's is bent forwards, suggesting a painful awareness and repentance, while Eve's hangs backwards, as though intent on communicating her suffering to the whole world.

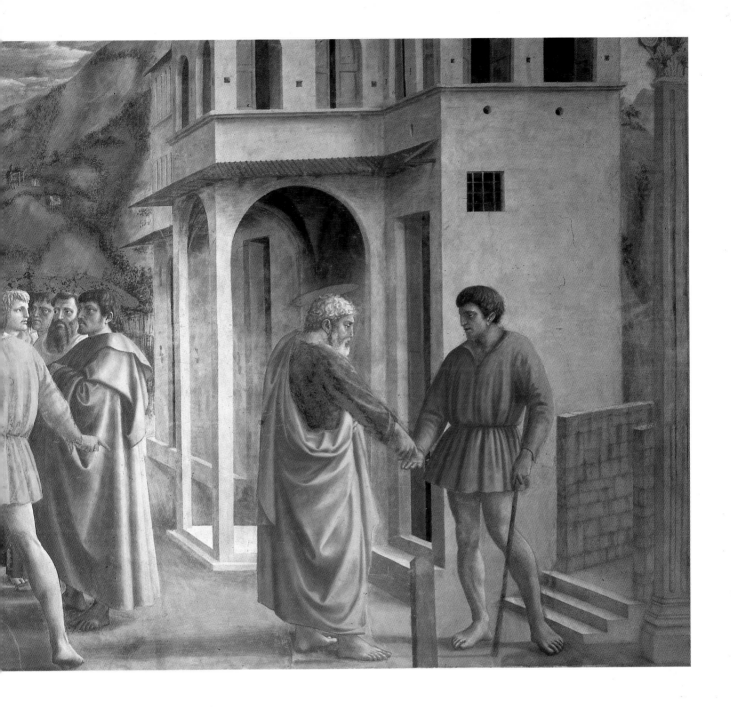

The Tribute Money

The episode depicts the arrival in Capernaum of Jesus and the Apostles: the description is based on the account given in Matthew's Gospel (17: 24-27). Masaccio has included the three different moments of the story in the same scene: the tax collector's request, with Jesus's immediate response indicating to Peter how to find the money necessary, is illustrated in the centre; Peter catching the fish in Lake Gennesaret and extracting the coin is shown to the left; and, to the right, Peter hands the tribute money to the tax collector in front of his house. This episode, stressing the legitimacy of the tax collector's request, has been interpreted as a reference to the lively controversy in Florence at the time on the proposed tax reform; the controversy was finally settled in 1427 with the institution of the Catasto, an official tax register, which allowed a much fairer system of taxation in the city (Procacci, 1951; Meiss, 1963; Berti, 1964).

But there are other allusions and references which have been pointed out by scholars. Peter's action could be a reference to the strategy of Pope Martin V, aiming at reconfirming the supremacy of the Church, and the coin found in the lake of Gennesaret refers to Florence's maritime concerns, promoted through the activity of Brancacci, the city's maritime consul (Steinbart, 1948). Masaccio's reference

to the Gospel according to Matthew is perhaps intended as a reminder of the principle that the Church must always pay its tributes with funds obtained from external sources and not from its own properties (Meller, 1961).

It is our opinion, and one we have expressed before (Casazza, 1986), that the episode is just one element of the *historia salutis* (and one must not forget that Meiss in 1963, basing himself on Augustine's interpretation of the episode, had already stated that the religious meaning of this story is redemption through the Church). This does not, however, exclude further possible meanings and references: such as, for example, a reiteration of the political supremacy of the Church, occasioned perhaps by the Hussite heresy and the Church's reaction against it, led by Pope Martin V and Cardinal Branda Castiglione (Von Einem, 1967); or the connection with the scene of the *Expulsion*, since Jesus Christ's gesture points towards the gate to the Garden of Eden in that fresco (in other words the Kingdom of Heaven), whereas the tax collector's gesture points towards the chipped wooden pole, symbolizing the corruption of the world (Wakayama, 1978).

Ever since the earliest scholars began writing about this fresco they showed special interest in the realistic details, which they noticed and pointed out despite the disappearance of the colour caused by the lampblack and the thick gluey substance that misguided restorers repeatedly applied to the surface of the frescoes over the centuries. Today it has finally become easier to appreciate the wealth of fascinating details, thanks to the recent restoration: Peter's fishing rod, the large open mouth of the fish he has caught, described down to the smallest details, the transparent water of the lake and the circular ripples spreading outwards, toward the banks.

The awareness that they are about to witness an extraordinary event creates in the characters an atmosphere of expectation. Behind the group of people we can see a sloping mountainous landscape, with a variety of colours that range from dark green in the foreground to the white snow in the background, ending in a luminous blue sky streaked with white clouds painted in perfect perspective. The hills and the mountains that rise up from the plains, dotted with farmhouses, trees and hedges, have an entirely new and earthy concreteness: a perfect use of linear perspective, which will be taken up by Paolo Uccello, Domenico Veneziano and Piero della Francesca.

A more important element that contributes to the solemn gravity of the characters is their relationship to a new kind of classicism, a re-elaboration of Graeco-Roman models, which Masaccio had either studied first-hand or through the works of Giotto, Nicola, Giovanni and Andrea Pisano, or even in the more recent sculptures of Nanni di Banco or Donatello.

The figures are arranged according to horizontal lines, but the overall disposition is circular: this semicircular pattern was of classical origin (Socrates and his disciples), although it was later adopted by early Christian art (Jesus and the Apostles), and interpreted by the first Renaissance artists, such as Brunelleschi, as the geometric pattern symbolizing the perfection of the circle (Meiss, 1963). A circular arrangement had already been used by Giotto in Padua and by Andrea Pisano in the Florence Baptistry and in Orvieto.

The characters are entirely classical: dressed in the Greek fashion, with tunics tied at the waist and cloaks wrapped over their left shoulder, around the back, and clasped at the front, below their left forearm. And even Peter's stance, as he extracts the coin from the fish's mouth, with his right leg bent and his left one outstretched, is reminiscent of the postures of many statues by Greek artists, as well as reliefs on Etruscan funerary urns and Roman carvings.

In 1940 Longhi suggested that the entire episode was not autograph, and that the head of Christ was by Masolino: other scholars later agreed with this theory, including Meiss (1963), Berti (1964-68), Parronchi and Bologna (1966).

Thanks to the recent cleaning we are now able to study the pictorial technique in detail, since the surface has finally been freed of the substances added over the centuries. Technically, the head of Christ is not identical in execution to the rest of the fresco. And, according to Baldini, it is not executed in the same manner as the head of Adam in the fresco of the *Temptation* either.

29. Tribute Money, detail
Florence, Brancacci Chapel

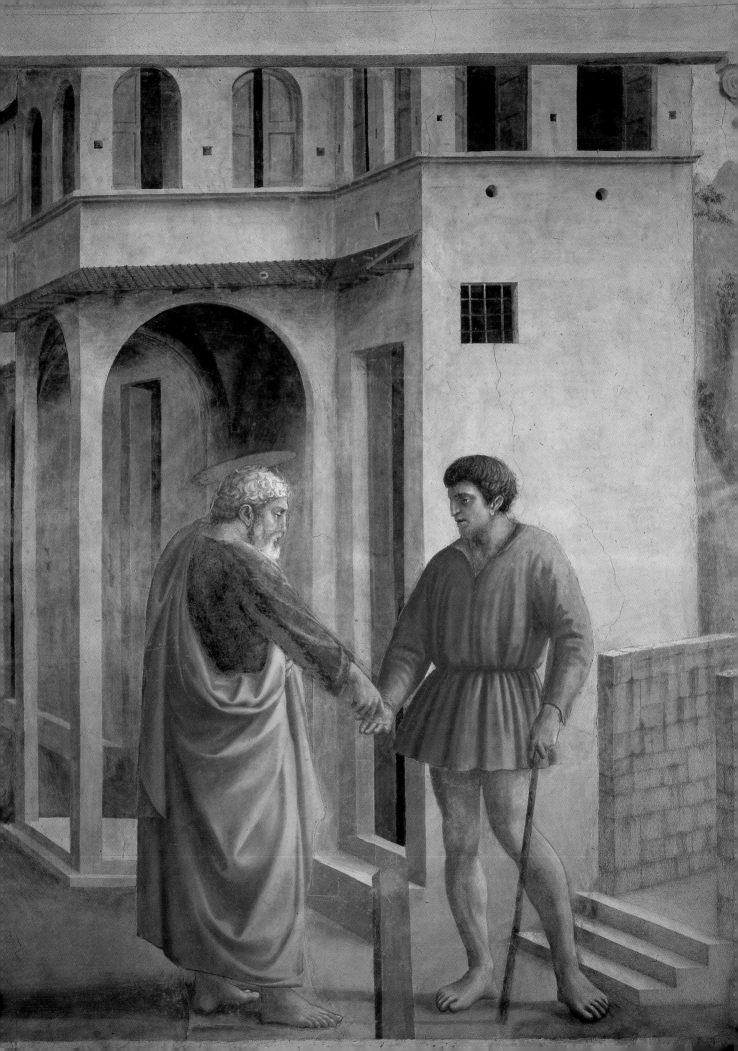

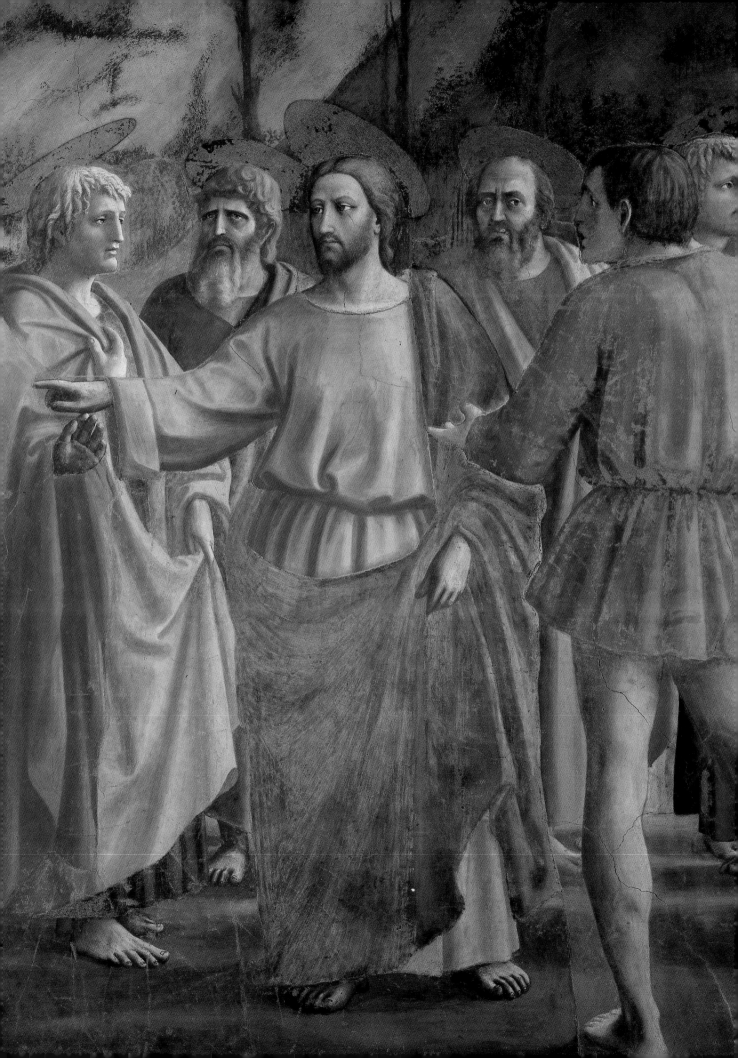

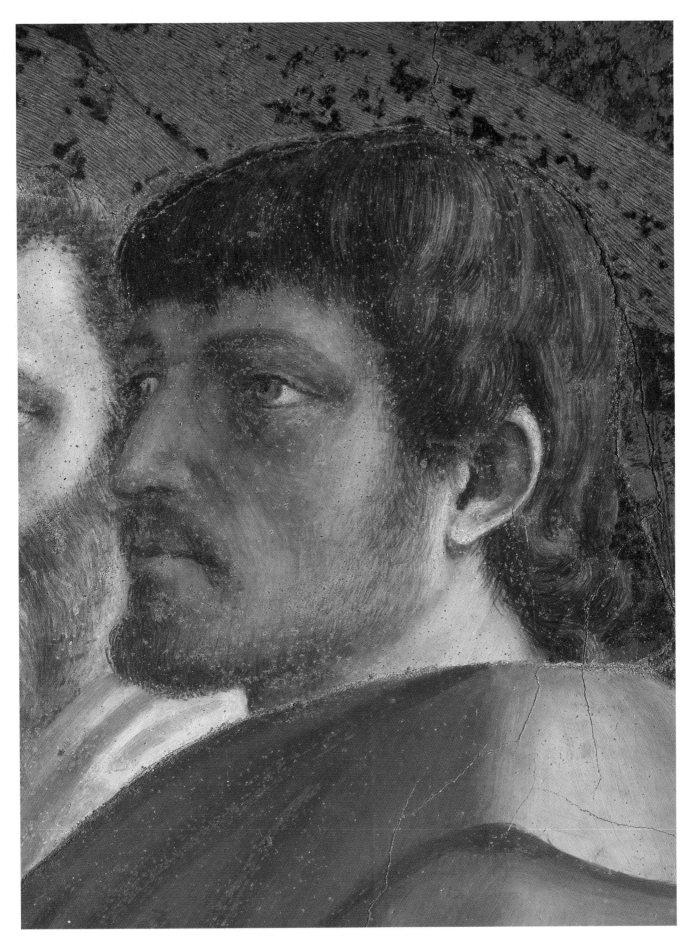

30,31. Tribute Money, details
Florence, Brancacci Chapel

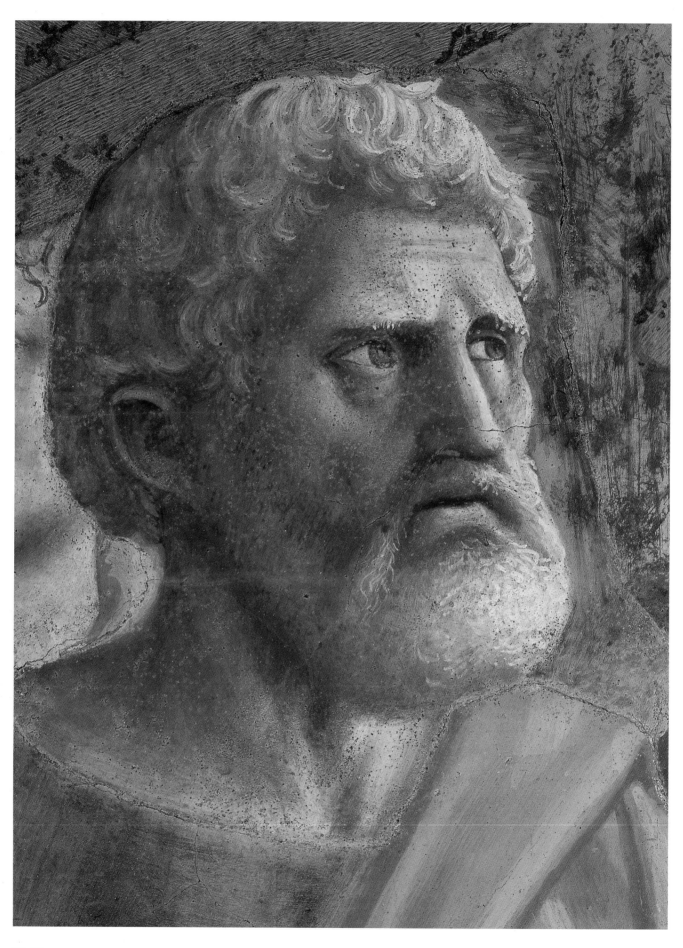

32,33. Tribute Money, details
Florence, Brancacci Chapel

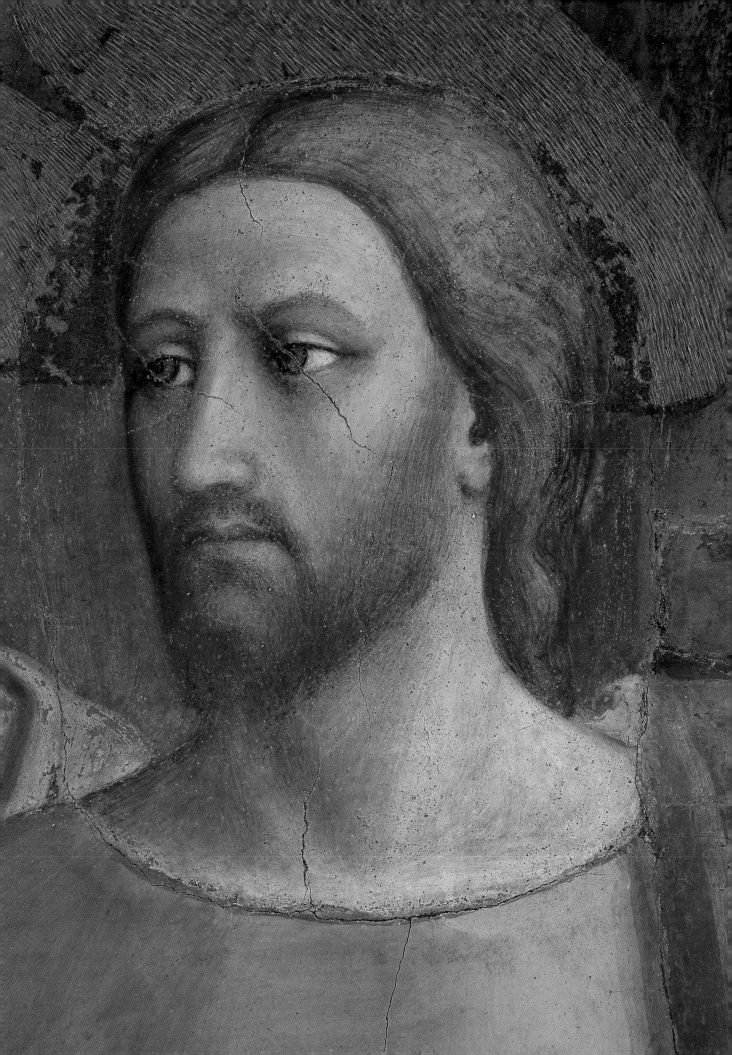

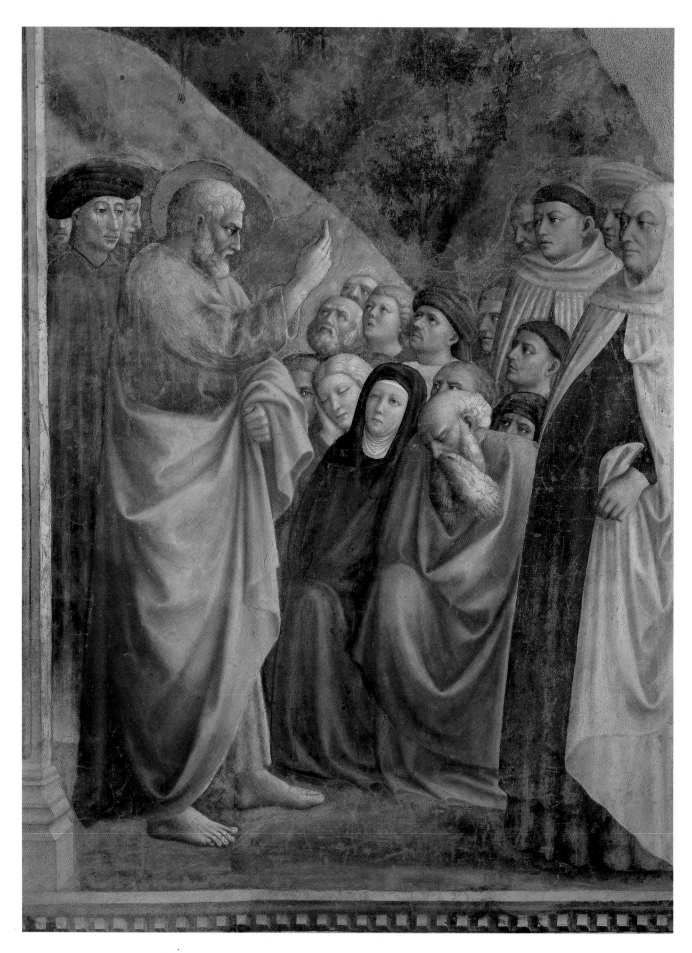

34. St Peter Preaching (Masolino)
255 x 162 cm. Florence, Brancacci Chapel

St Peter Preaching

This scene refers to Peter's sermon ("Ye men of Judaea, and all ye that dwell at Jerusalem, be this known unto you, and hearken to my words"), as recounted in the Acts of the Apostles, which he preaches in Jerusalem after the descent of the Holy Ghost on Pentecost. The fresco actually illustrates the final part of the sermon, when Peter says: "Repent, and be baptized every one of you in the name of Jesus Christ for the remission of sins, and ye shall receive the gift of the Holy Ghost."

It was Longhi in 1940 who first suggested that Masaccio must have had a hand in this fresco. He attributed to Masaccio the three bystanders to the left, behind St Peter ("their grim expression is truly modern"); this theory was accepted by Bologna (1966) and Parronchi (1966), who continued to support it even after Berti (1964) drew a different conclusion from a careful analysis of the *giornate*, or work days, dismissing the idea that Masaccio had had anything to do with the fresco at all (for he discovered that these three heads were painted on the same day as the head of St Peter).

Berti, who had already (1966) ruled out the possibility that there had been collaboration on the two frescoes ("the *Sermon* is entirely by Masolino, just as the *Baptism* is entirely by Masaccio"), has recently changed his opinion: after seeing the restored paintings, he now (1988-89) believes that this fresco was begun by Masaccio, who actually only executed the mountains. Conversely, he believes that the *Baptism of the Neophytes* was begun by Masolino, who also only painted the mountains in the background. But he still maintains that the three figures (which Parronchi now, in 1989, believes are by Masaccio) are indeed the work of Masolino, because of their resemblance to the three elegant men in the story of Tabitha.

According to Baldini (1989), the cleaning has given such a clear vision of the pictorial fabric that we can now attribute the fresco entirely to Masolino, who was working in total autonomy, following an established division of spaces and subjects, in harmony with the corresponding scene of the *Baptism* painted by Masaccio, according to a project that had been drawn up by the two artists together.

The Baptism of the Neophytes

This episode is taken from the Acts of the Apostles (2:41): "Then they that gladly received his word were baptized: and the same day there were added unto them about three thousand souls." In the overall plan, this episode provides the link between the scenes on the upper level and those below, which are arranged from left to right.

Compared to the situation before the recent cleaning, this is the fresco that appears to have benefitted the most from the operation: the splendid colour tones have been rediscovered, as well as the lighting and the draughtsmanship, justifying the fact that this fresco has always been considered a work of unparalleled beauty, from the Anonimo Magliabechiano ("among the other figures, there is one shown trembling ... an extraordinary sight") to Vasari ("a nude trembling because of the cold, amongst the other neophytes, executed with such fine relief and gentle manner, that it is highly praised and admired by all artists, ancient and modern").

Behind this nude, there is another neophyte still fully clothed, in a red and green iridescent cloak. The execution of this figure displays such skill and a sure hand, as well as such a novel pictorial technique, especially in the shimmering iridescence of the cloth, that it almost seems to herald the art of Michelangelo in the Sistine Chapel, or the reddish and purple garments so dear to the early Mannerists.

The cold, flowing water of the river presses against the legs of the kneeling neophyte; the water that Peter pours from the bowl, with a gesture rather like that of a farmer sowing his seeds, splashes onto the man's head, drenching his hair, and dribbling off in rivulets. Again, as it falls into the river, it splashes and forms little bubbles. These realistic details are not fully visible from the ground, just as it is difficult to make out the stubble growing on the face of one of the onlookers, or the ear of another folded over under his turban.

There are twelve neophytes, plus St Peter. In the *Tribute Money* the group of the twelve Apostles form a "human Colosseum," whereas here the characters give rise to an endless procession, which appears to continue into the valley, beyond the painted pilaster strip.

In the past several scholars have suggested that Masaccio must have been helped in this fresco by Masolino or Filippino. Longhi (1940) suggested that

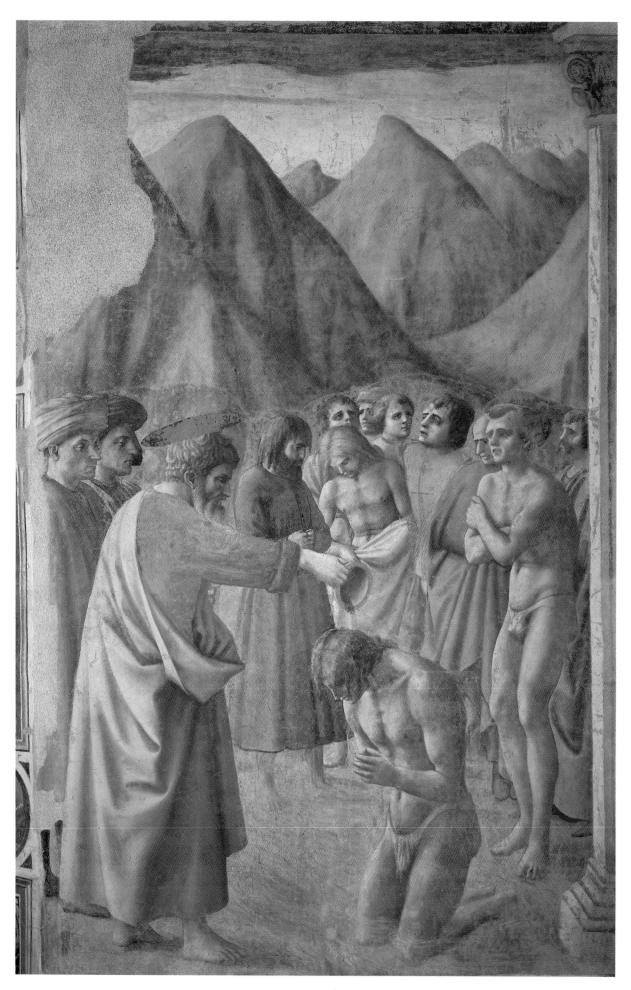

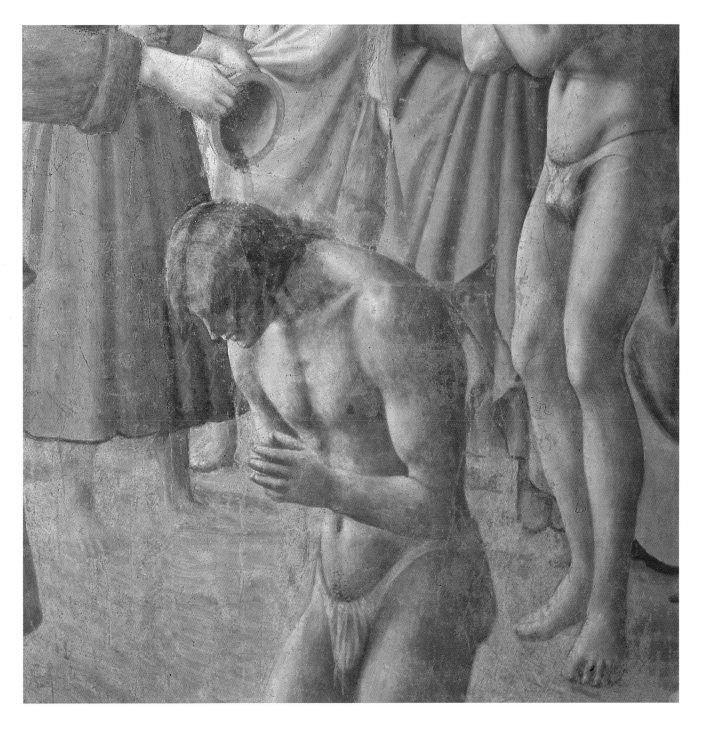

35,36. Baptism of the Neophytes (Masaccio) 255 x 162 cm. Florence, Brancacci Chapel

the two figures to the left, behind St Peter, were the work of Filippino. This attribution, although accepted by Bologna (1966), was rejected by Salmi (1947), who defined the *Baptism* "a terribly badly damaged painting, but one which can still be judged": he believed that the head of St Peter had been repainted by Filippino, but that all the other figures were definitely the work of Masaccio, albeit retouched and disfigured by alterations carried out at a later date. Procacci (1951), followed by Parronchi (1966), believed that the head of St Peter and the two onlookers were by Masolino; but today, after the restora-

tion he has no doubts that the entire scene is by Masaccio. Parronchi (1989) now suggests that the two portraits are the work of some unidentified assistant of Masaccio's, while he considers the head of St Peter a very weak piece of work, of such inferior quality that it is certainly neither by Masaccio nor by Masolino.

And once again, after the cleaning, some scholars have brought up again the theory of a collaboration between Masaccio and Masolino on this fresco as well: for example Berti (1989), who suggests that Masolino was entirely responsible for the landscape.

35

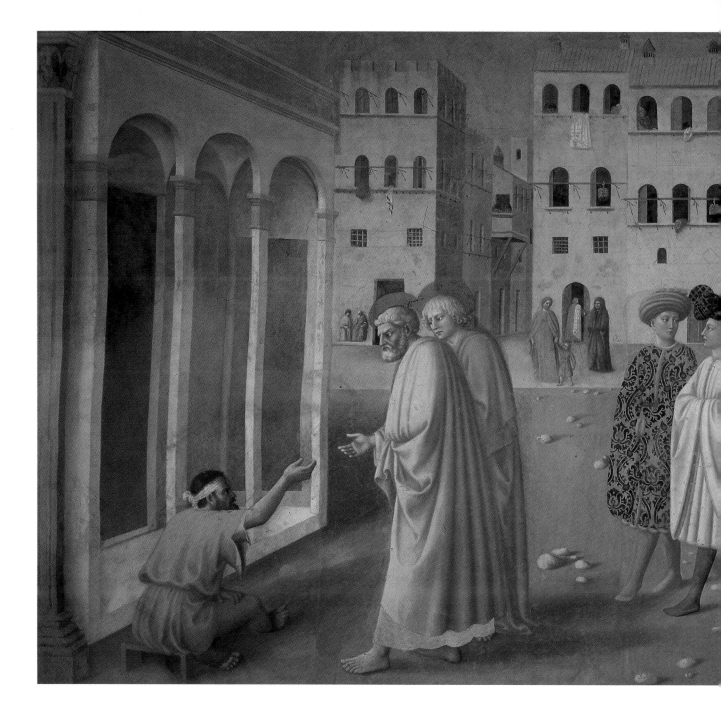

The Healing of the Cripple and the Raising of Tabitha

Both the events depicted in this fresco are recount-
ed in the Acts of the Apostles: the healing of the crip-
ple in Jerusalem (3: 1-10) and the raising of Tabitha
in Joppa (9: 36-43). Masolino sets both events in the
same town, although they had actually taken place
in different cities and at different times.

In the square there are two elegantly dressed
characters, in the centre of the scene, who separate
but also provide the link between the two miraculous
events. The presence of these two figures, and also
the characters depicted in the background in front of
the houses, makes the two events look like normal
everyday occurrences in the life of a city. The square

resembles a contemporary Florentine piazza and the
houses in the background, although none of them
is strictly speaking an accurate portrayal of an exist-
ing building, convey the idea of Florentine architec-
ture, as we still know it today. Even the paving of
the street, different from that of the square, is a note
of pure realism: the cobblestones, decreasing in size
as they recede, also serve to emphasize the perspec-
tive of the composition.

And there are other elements which contribute to
this description of everyday city life: the flower pots
on the window sills, the laundry hanging out to dry,
the bird cages, the two monkeys, the people lean-

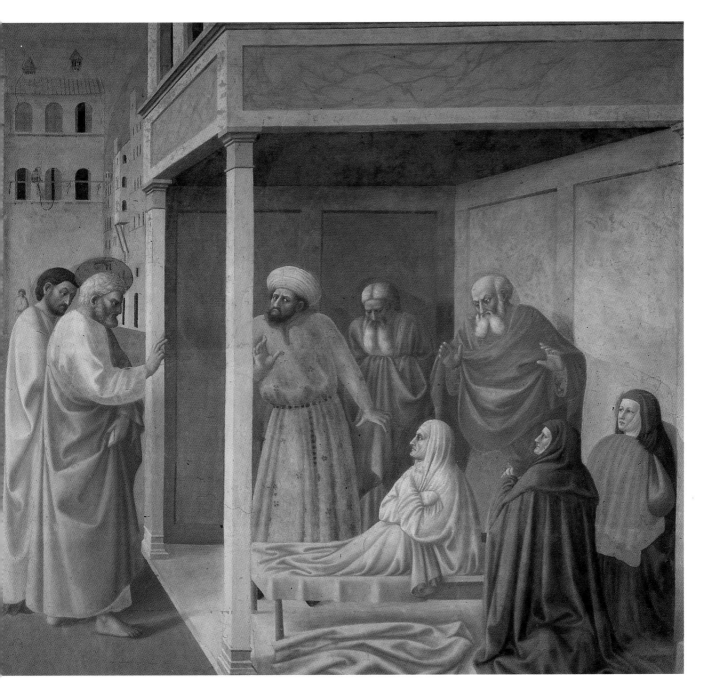

37. *Healing of the Cripple and Raising of Tabitha (Masolino)*
255 x 598 cm. Florence, Brancacci Chapel

ing out of the windows to chat with their neighbours, and so on.

In the past the loggia to the left had been considered by critics to be architecturally fragile and unconvincing. But now, thanks to the restoration, we can make out the structural elements: from the smooth capitals of the pilasters, to the red plaster inside the cross-vaults.

And even in the righthand loggia, where the miracle of the raising of Tabitha takes place, the classical, Albertian colour pattern of the surfaces and the entablatures increases the solidity of the architecture.

Throughout the 19th century and the first deca-

des of the 20th, scholars attributed this fresco to Masaccio, until Mesnil (1929) re-attributed it to Masolino. Other critics, although basically agreeing with Mesnil's attribution, claimed that there were sections painted by Masaccio. Longhi was the first (1940) to suggest that Masaccio was responsible for the entire architectural background of the scene, including the figures in the background. This theory was accepted by almost all later scholars.

Since the restoration, now that the pictorial techniques can be clearly distinguished, we can rule out any intervention by Masaccio at all, at any rate in the actual execution.

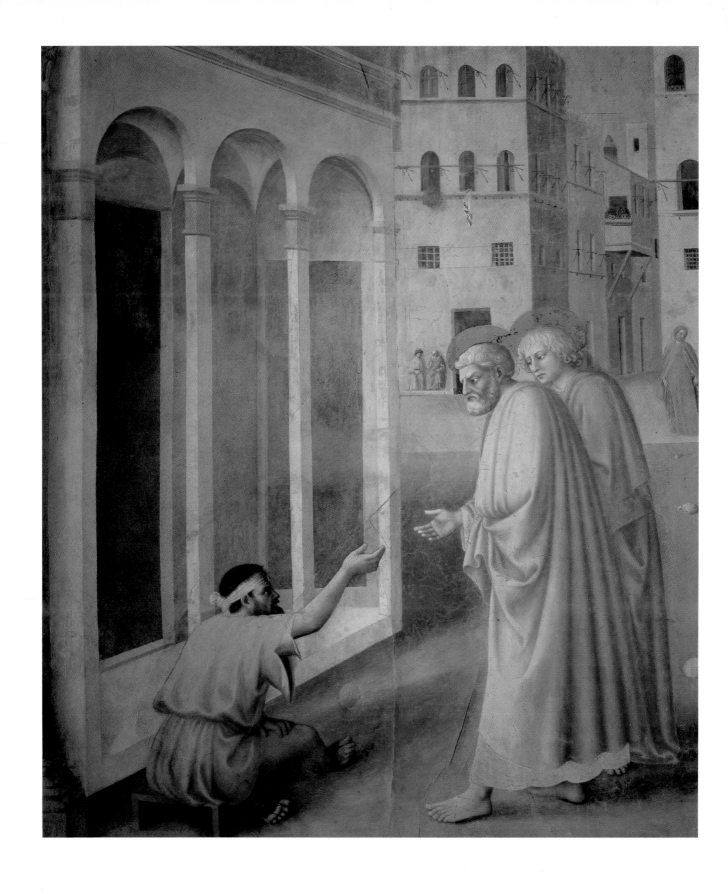

38,39. Healing of the Cripple, details
Florence, Brancacci Chapel

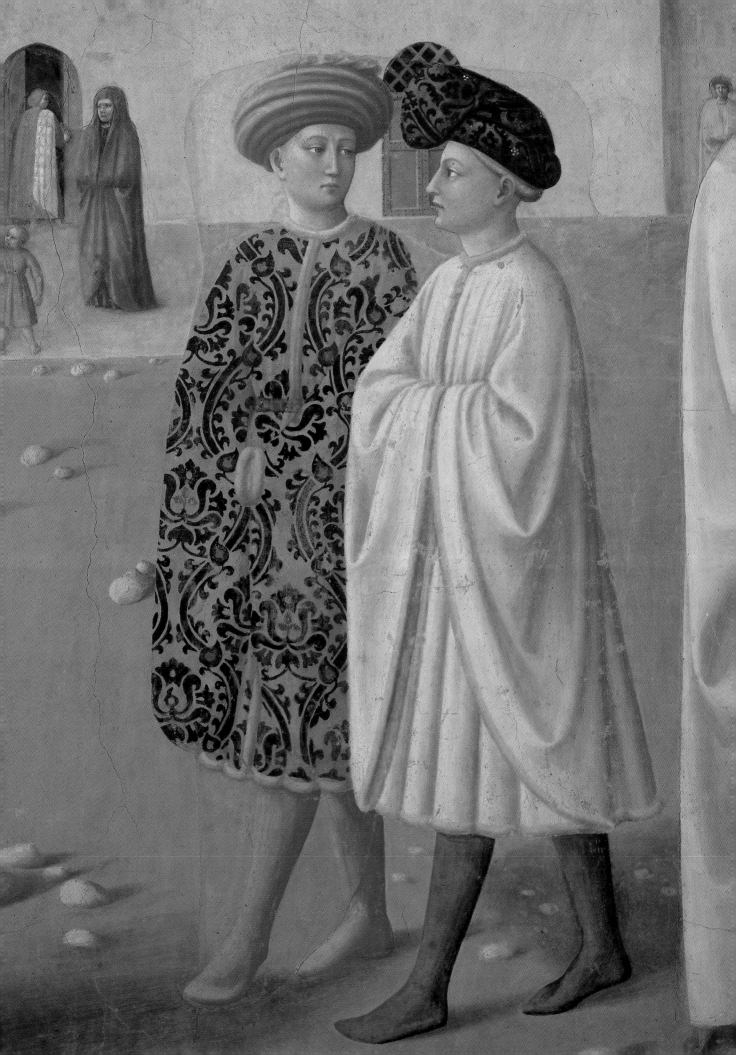

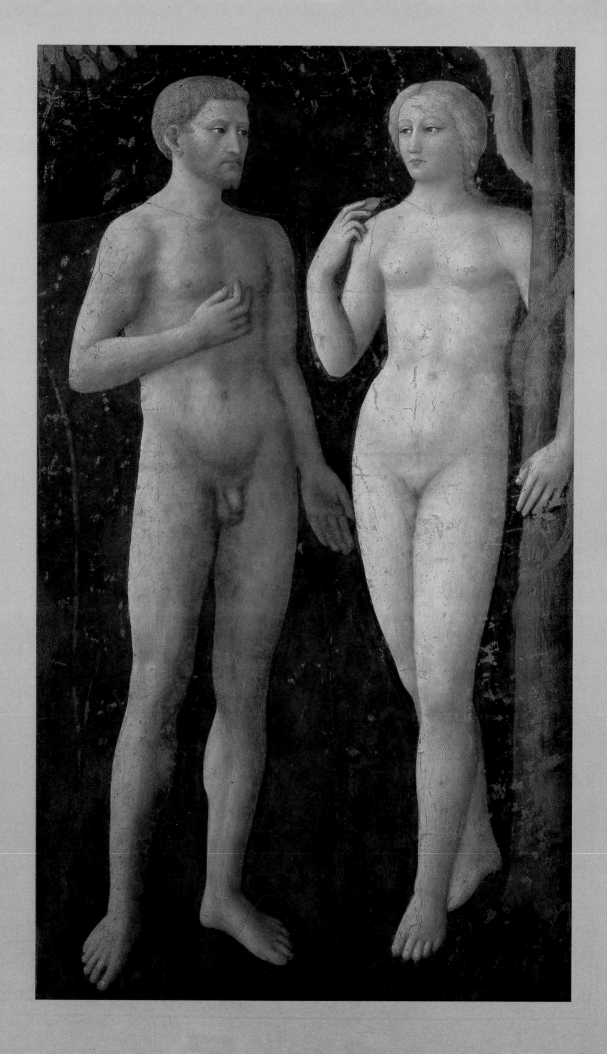

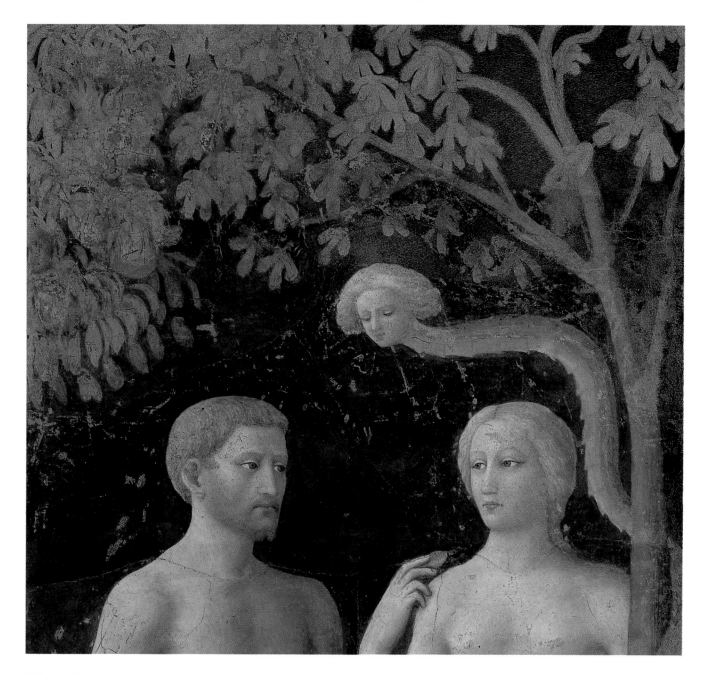

The Temptation

The construction of the new entrance arch to the chapel in the 18th century damaged the top of this
21 fresco, as well as the neighbouring *Expulsion from the Garden of Eden*. The top of the trees and the portion of sky which must presumably have appeared above them is missing.

In this scene Masolino makes use of the most popular and traditional iconography of the period and the two figures, both in their gestures and in their expressions, are courtly and elegant: a mood which has always been contrasted with the atmosphere in Masaccio's fresco opposite, interpreted as a power-

ful manifesto of a new cultural and artistic vision, one of great spiritual harmony and technical ability.

Although traditionally attributed to Masolino, there was a period during which it was believed to be a very early work by Masaccio. In this century, however, all critics and scholars have always agreed that it was painted entirely by Masolino: in fact, it is considered so typically a work by Masolino that it is used as the perfect example to distinguish between the art of the two painters.

Here, too, the foliage that had been added to cover the nude bodies has been removed.

40,41. The Temptation (Masolino)
208 x 88 cm. Florence, Brancacci Chapel

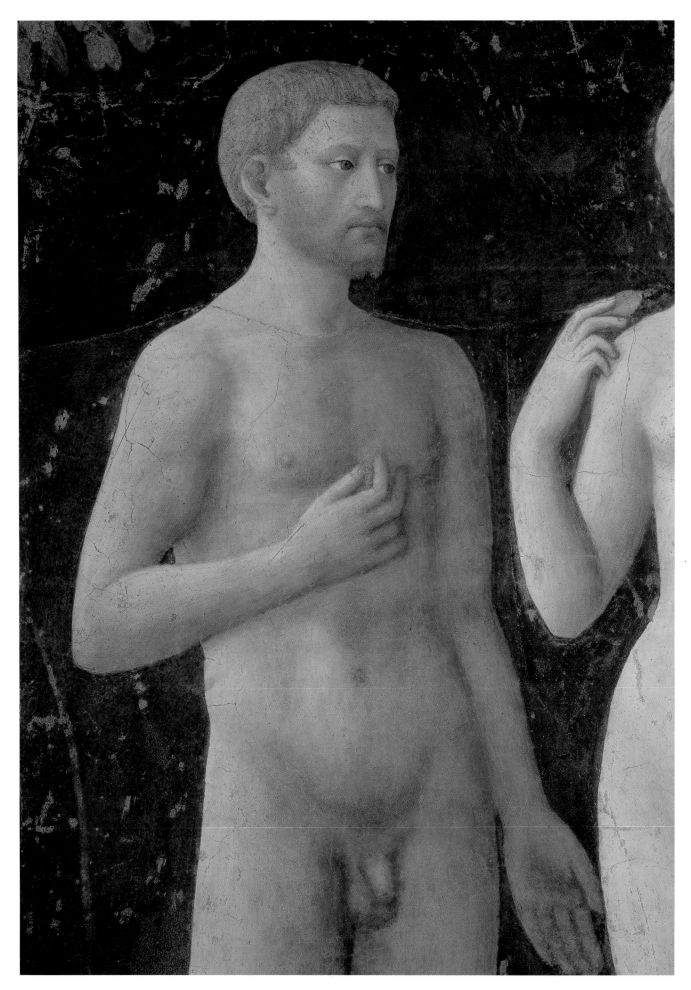

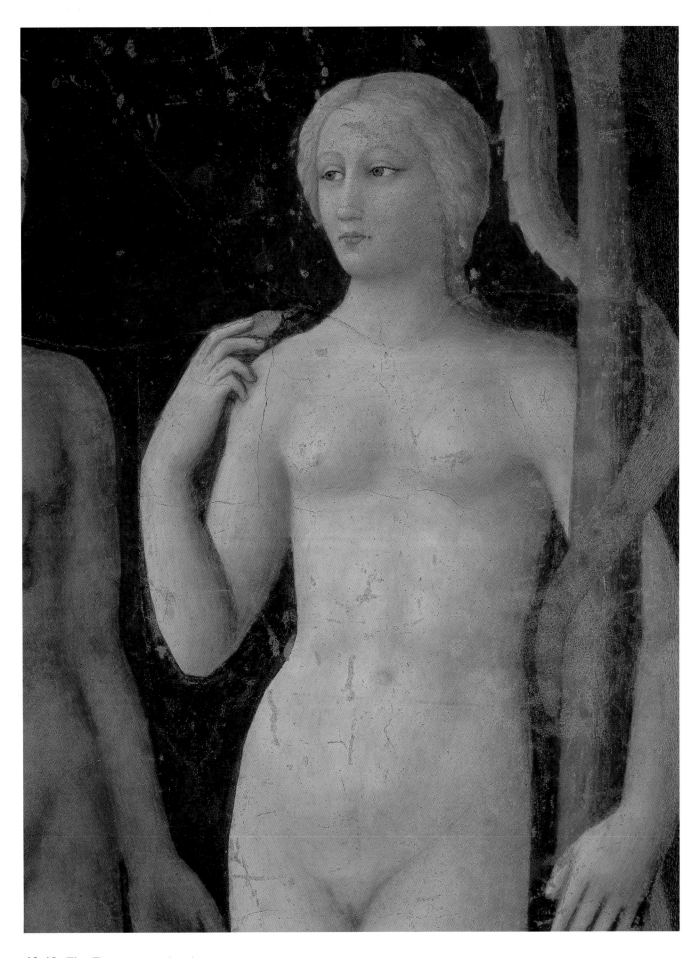

42,43. The Temptation, details
Florence, Brancacci Chapel

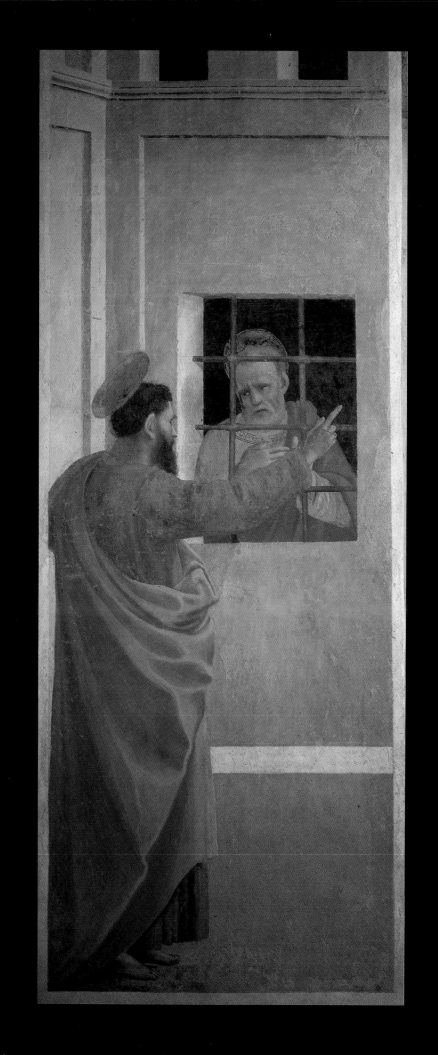

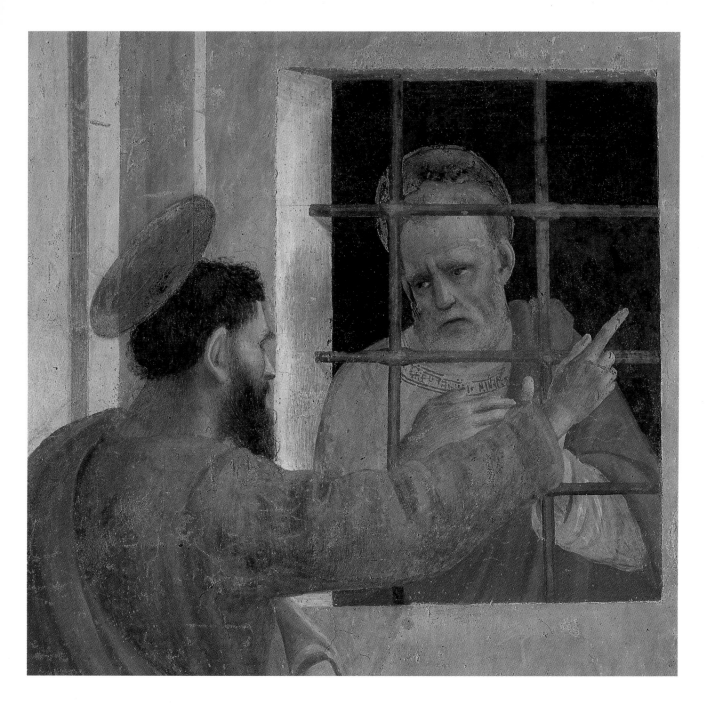

St Paul Visits St Peter in Prison

46 This episode comes before the *Raising of the Son of Theophilus*. The Golden Legend tells the story of Theophilus, Prefect of Antioch, who put Peter in prison; and there the Apostle would certainly have languished for the rest of his days, had not St Paul, who frequently visited him in his cell, gone to Theophilus and told him that Peter had the power to resurrect the dead. Theophilus was very interested and told Paul that he would have Peter released immediately if he were able to resurrect his son, who had died fourteen years previously.

For a long time the fresco was attributed to Masaccio. Actually, it is the most Masaccesque of Filippino's paintings, so much so that it has been suggested (Salmi, 1947; Fiocco, 1957) that he may have been working from a sinopia prepared by Masaccio.

44,45. St Paul Visits St Peter in Prison (Filippino Lippi)
230 x 88 cm
Florence, Brancacci Chapel

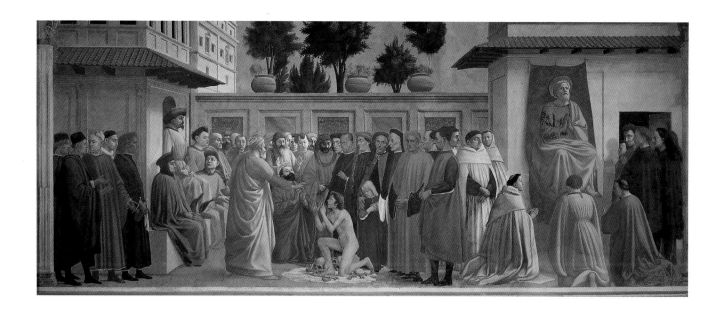

The Raising of the Son of Theophilus and St Peter Enthroned

This scene illustrates the miracle that Peter performed after he was released from prison, thanks to Paul's intercession. According to the account in the Golden Legend, once out of prison, Peter was taken to the tomb of the son of Theophilus, Prefect of Antioch. Here St Peter immediately resurrected the young man who had been dead for fourteen years. As a result, Theophilus, the entire population of Antioch and many others were converted to the faith; they built a magnificent church and in the centre of the church a chair for Peter, so that he could sit during his sermons and be heard and seen by all. Peter sat in the chair for seven years; then he went to Rome and for twenty-five years sat on the papal throne, the cathedra, in Rome.

Masaccio sets the scene in a contemporary church, with contemporary ecclesiastical figures (actually the Carmelite friars from Santa Maria del Carmine) and a congregation that includes a self-portrait and portraits of Masolino, Leon Battista Alberti, Brunelleschi.

Vasari, in his Life of Masaccio, mentions the work of Filippino, but later chroniclers refer to all the frescoes in the chapel as by Masaccio, with only a few rare exceptions (Borghini, Richa). It was not until the 19th century that Rumohr, followed by Gaye, once again pointed out the work of Filippino, distinguishing it from that of Masaccio; and since then critics have been in almost total agreement with his theory.

Scholars have suggested that Filippino was commissioned to complete the work that Masaccio had left unfinished or to repair sections which been damaged or destroyed because they depicted characters that were enemies of the Medici, like the Brancacci. There is no doubt that the Brancacci family was subjected to something similar to a *damnatio memoriae* after they had been declared enemies of the people and exiled.

Vasari had already identified a number of contemporary figures in those painted by Filippino: the resurrected youth was supposedly a portrait of the painter Francesco Granacci, at that time hardly more than a boy; "and also the knight Messer Tommaso Soderini, Piero Guicciardini, the father of Messer Francesco who wrote the Histories, Piero del Pugliese and the poet Luigi Pulci."

In a study of the possible portraits and of the iconography of the fresco, Meller (1961) confirms the identifications made by Vasari and suggests others, presumably already planned in Masaccio's original sinopia, indicating that the fresco was intended to convey a political message: the Carmelite monk is a portrait of Cardinal Branda Castiglione; Theophilus is Gian Galeazzo Visconti; the man sitting at Theophilus's feet is Coluccio Salutati. And the four men standing at the far right are, starting from the right, Brunelleschi, Leon Battista Alberti, Masaccio and Masolino.

46,47. Raising of the Son of Theophilus and St Peter Enthroned (Masaccio and Filippino Lippi)
230 x 598 cm
Florence, Brancacci Chapel

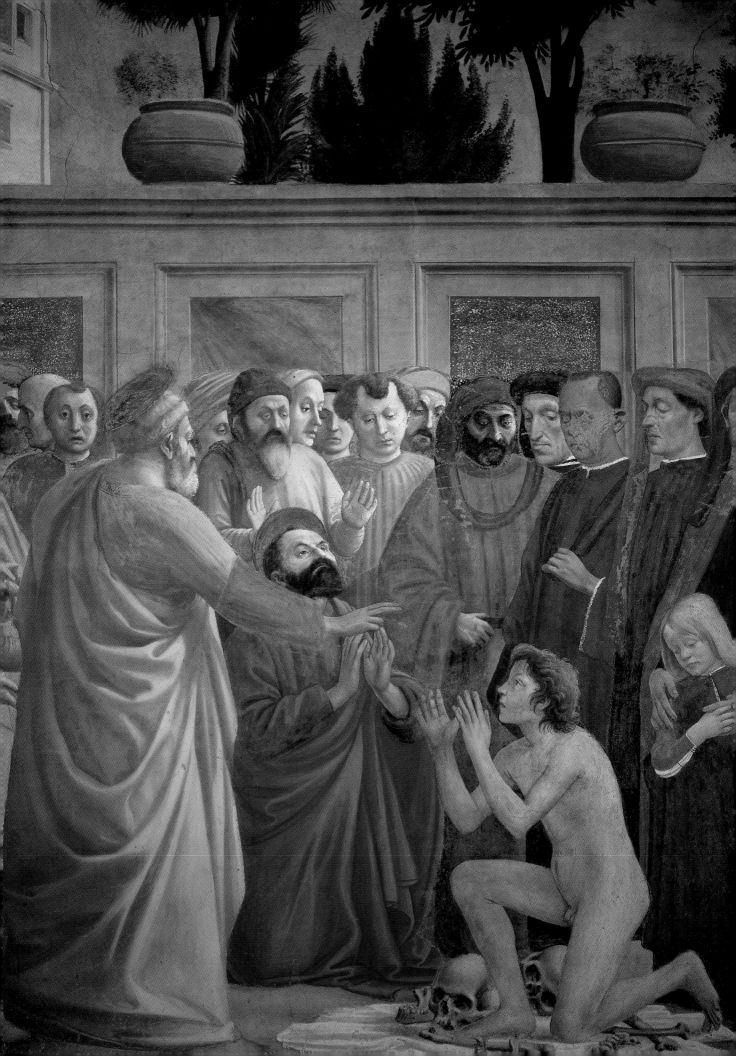

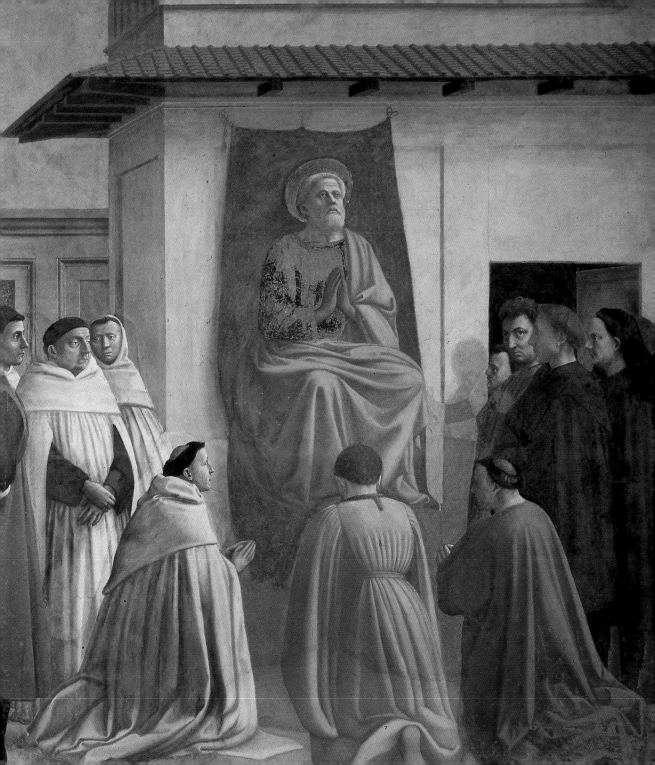

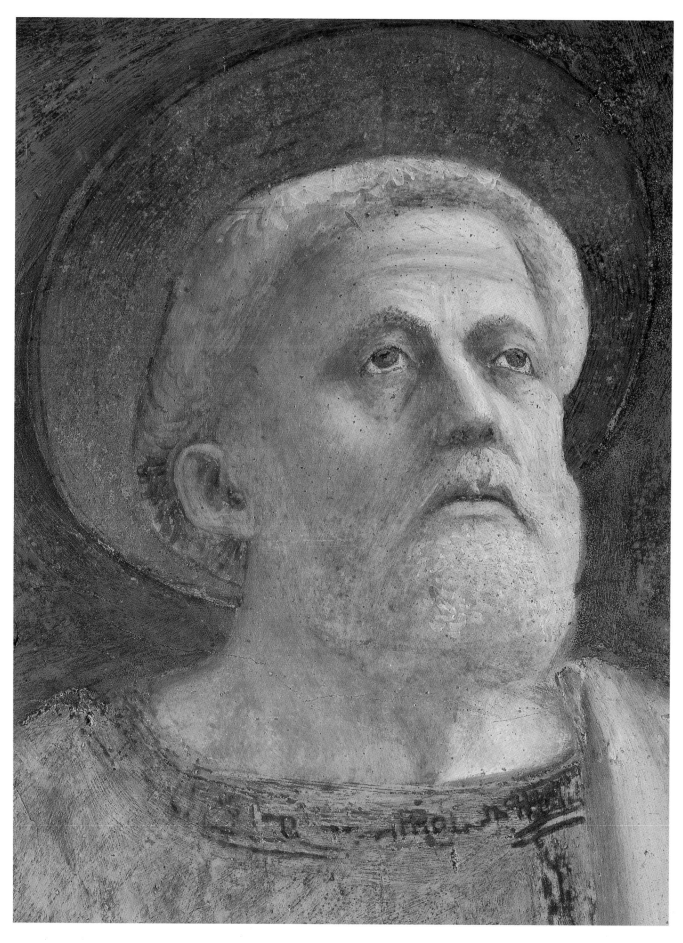

48,49. St Peter Enthroned
Florence, Brancacci Chapel

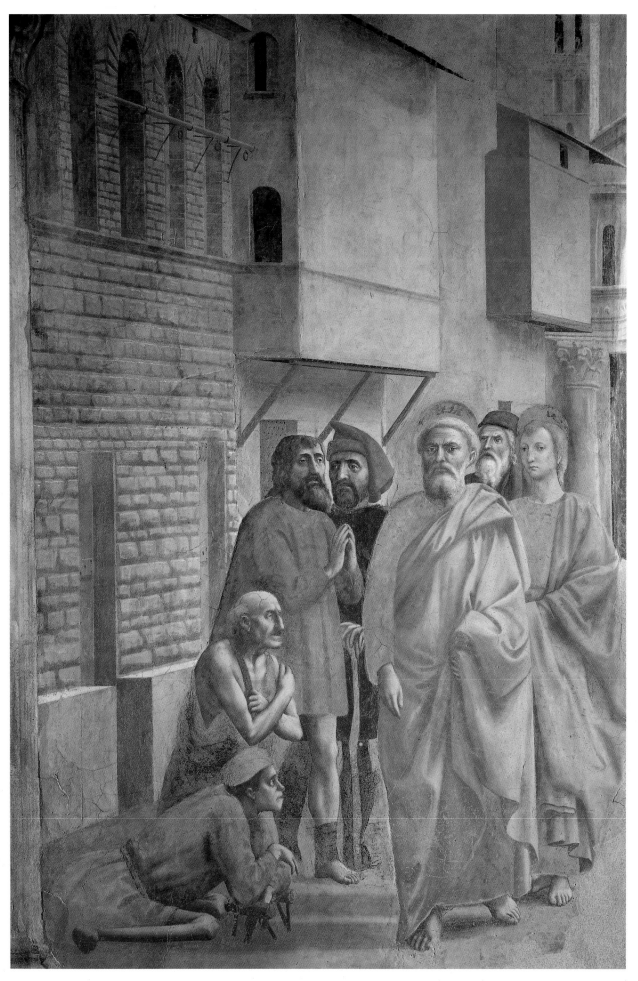

50. St Peter Healing the Sick with his
Shadow (Masaccio)
230 x 162 cm
Florence, Brancacci Chapel

51. Palazzo Antinori in Florence

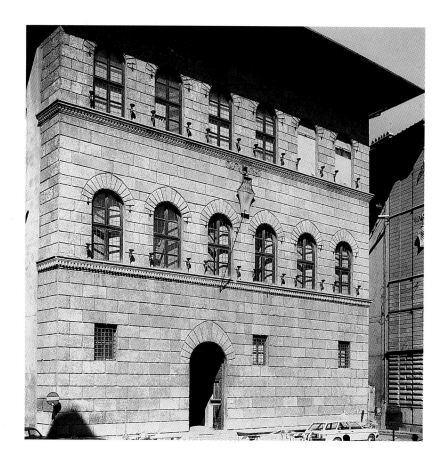

St Peter Healing the Sick with his Shadow

In the Acts of the Apostles (5: 12-14) this episode is recounted immediately after the story of Ananias, illustrated in the fresco to the right.

Scholars have never doubted that this scene is entirely by Masaccio. Starting with Vasari (1568), who used the man with the hood as the portrait of Masolino he put on the frontispiece of his biography of the artist, all later scholars have tried to identify the contemporary characters portrayed in the scene. Poggi (1903) noticed that the bearded man holding his hands together in prayer is the same person as one of the Magi in the predella of the Pisa Polyptych, now in Berlin; Meller (1961) has suggested that it may be a portrait of Donatello, while Berti (1966) thinks that Donatello is the old man with a beard between St Peter and St John. But for Parronchi (1966) this character is Giovanni, nicknamed Lo Scheggia, Masaccio's brother; while Meller (1961) believes that he is a self-portrait.

The removal of the altar has uncovered a section of the painting, at the far right, which is of fundamental importance in understanding the episode: this section includes the facade of a church (Baldini, 1986), a bell tower, a stretch of blue sky and a column with a Corinthian capital behind St John. Also extremely important is the way Masaccio conceived the right-hand margin of the composition: as Baldini (1986) pointed out, to give the space a more regular geometrical construction, Masaccio has created "a complex play of optical effects and of perspective, as we can see in the lower section of the window jamb, where he has solved graphically an architectural problem, pictorially adjusting the faulty plumb-line of the edge of the jamb and the end wall; he makes the story, and therefore some of the background constructions, continue on the jamb."

The street, depicted in accurate perspective, is lined with typically mediaeval Florentine houses; in fact, the scene appears to be set near San Felice in Piazza, which had a commemorative column standing in front of it (Berti, 1988). But the splendid palace in rusticated stone looks like Palazzo Vecchio in the lower section (the high socle that we can still see on the facade along Via della Ninna, with the small built-in door), although it is much more similar to Palazzo Pitti in the upper part (the windows with their rusticated stone frames). And in some details, such as the exact geometrical scansion of the ashlars, it is an anticipation of later facades, first and foremost Palazzo Antinori.

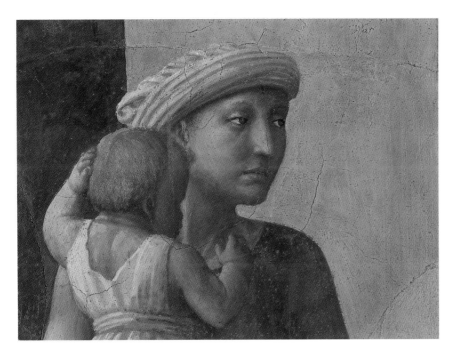

52,53. Distribution of Alms and Death of Ananias (Masaccio)
230 x 162 cm
Florence, Brancacci Chapel

The Distribution of Alms and the Death of Ananias

This episode is taken from the account in the Acts of the Apostles (4: 32-37 and 5: 1-11): "For as many as were possessors of lands or houses sold them, and brought the prices of the things that were sold, and laid them down at the apostles' feet: and distribution was made unto every man according as he had need. ... But a certain man named Ananias, with Sapphira his wife, sold a possession, and kept back part of the price, his wife also being privy to it, and brought a certain part, and laid it at the apostles' feet. But Peter said, Ananias, why hath Satan filled thine heart to lie to the Holy Ghost, and to keep back part of the price of the land? ... why hast thou conceived this thing in thine heart? thou hast not lied unto men, but unto God. And Ananias hearing these words fell down, and gave up the ghost."

Masaccio brings together the two moments of the story: Peter distributing the donations that have been presented to the Apostles and the death of Ananias, whose body lies on the ground at his feet. The scene takes place in a setting of great solemnity, and the classical composition is constructed around opposing groups of characters.

No scholar has ever doubted that the entire scene is by Masaccio, except for minor cases of details having been retouched (pointed out by Salmi, 1947), such as certain parts of Ananias's body, small sections to the far left where the colour had come off, and even tiny areas on St Peter himself.

The recent restoration has provided us with interesting information: for example, we can now see that there are several details that are not the work of

Masaccio, such as St John's pink cloak and his tunic, and Ananias's hands. Baldini (1986) has suggested that all these elements were repainted by Filippino, all in one day's work, over Masaccio's original fresco.

As well as a reference to salvation through the faith, this fresco has also been interpreted (Berti, 1964) as another statement in favour of the institution of the Catasto, for the scene describes both a new measure guaranteeing greater equality among the population and the divine punishment of those who make false declarations. And it has also been suggested (Meller, 1961) that the fresco contains a reference to the family who commissioned the cycle: the man kneeling behind St Peter's arm has been identified as Cardinal Rinaldo Brancacci, or alternatively as Cardinal Tommaso Brancacci.

Due to the interference of the altar and marble balustrade set up in the 18th century, no scholar (with the exception of Mesnil, 1912, who hazarded a suggestion along these lines) had been able to notice that the two episodes on the end wall are ideally part of a single composition, although they are intended to be seen from different viewpoints: the *Distribution of Alms* along the corner axis of the building in the centre, from a position to the right of the entrance, while the scene of *Peter Healing the Sick with his Shadow* is intended to be viewed from the middle of the chapel, from fairly close up. The connection between the two scenes is further emphasized by the fact that on the window side neither has pilaster strips framing the outer edge. The original two-light window, so narrow and tall, did not really interrupt the

50

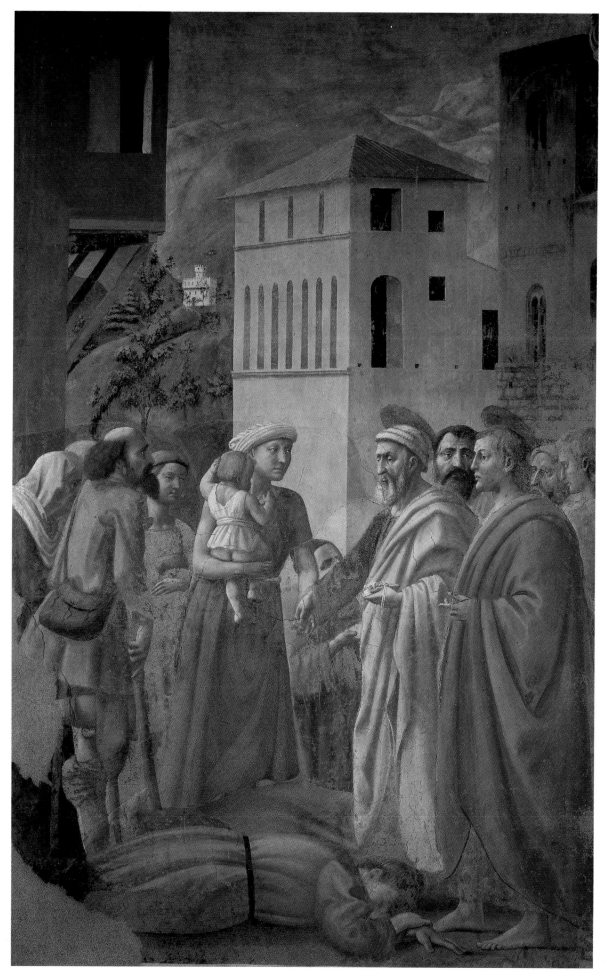

continuity of the wall space: on the contrary, its concave surface provided an ideal connection with the space outside, not as a further background element, but rather as a real source of light, enhancing the three-dimensional features of the characters and contributing to the contrast between light and dark areas (Rossi, 1989).

The Disputation with Simon Magus and the Crucifixion of Peter

This fresco depicts the two last episodes from the story of the life of Peter: to the right we see him, with St Paul, in his dispute with Simon Magus in front of the Emperor; to the left, his *Crucifixion*.

Baldini (1984) suggests that Masaccio had originally painted the last scene of the cycle, the *Crucifixion of Peter*. But that fresco was then destroyed when the Madonna del Popolo was placed on the altar, so

that when Filippino was called in to complete the unfinished cycle and repair the damaged sections, he was also asked to add the scene of the death of Peter on the empty wall space.

Among the portraits Filippino has included in his fresco, the most interesting are the following: a self-portrait (the first figure to the left, looking towards the spectator); the first man to the right of the three 58

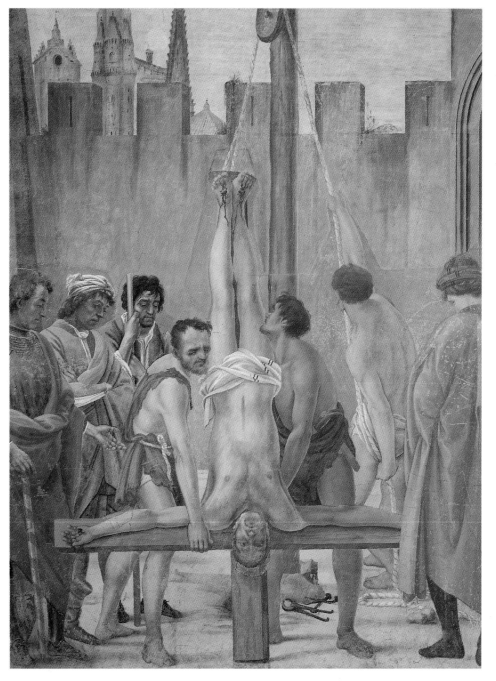

54-56. Disputation with Simon Magus and Crucifixion of Peter (Filippino Lippi)
230 x 598 cm
Florence, Brancacci Chapel

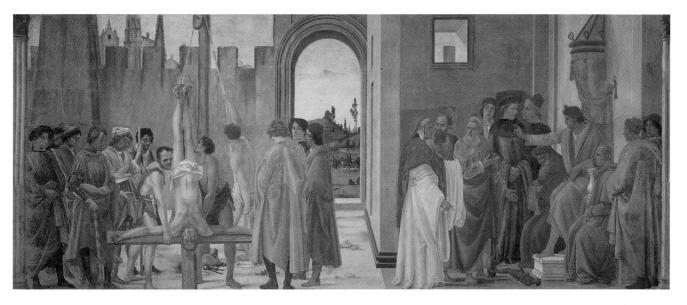

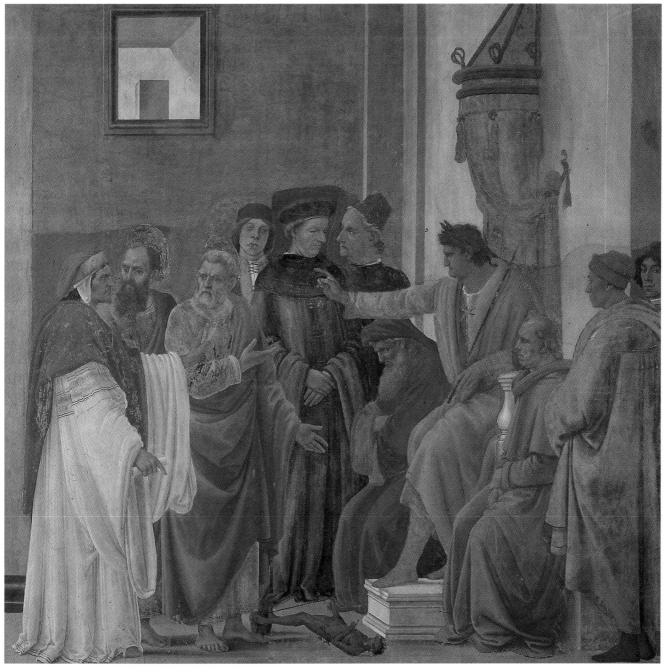

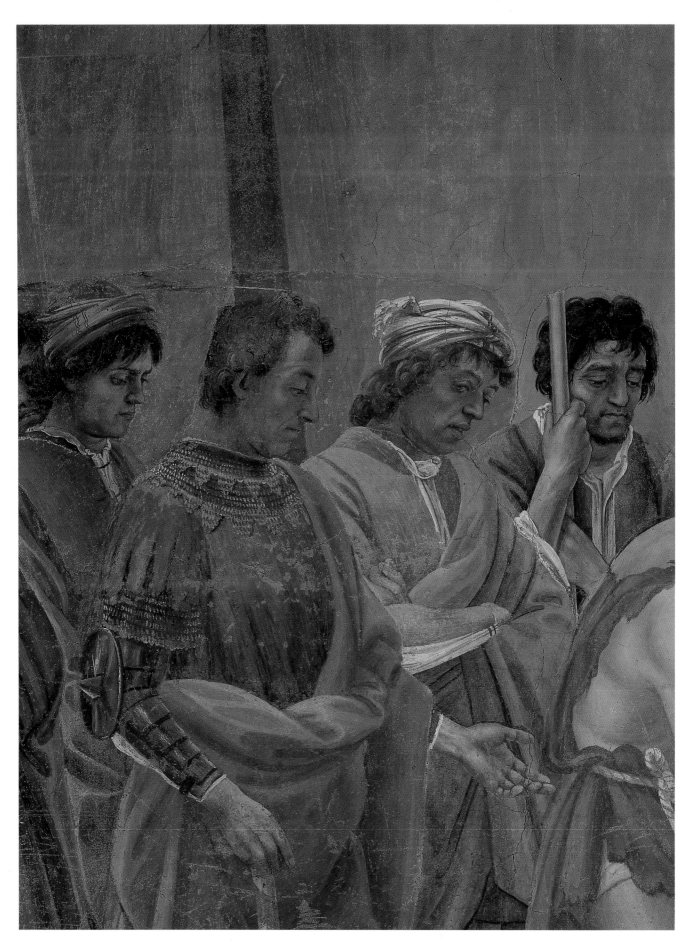

57,58. Crucifixion of Peter, details
Florence, Brancacci Chapel

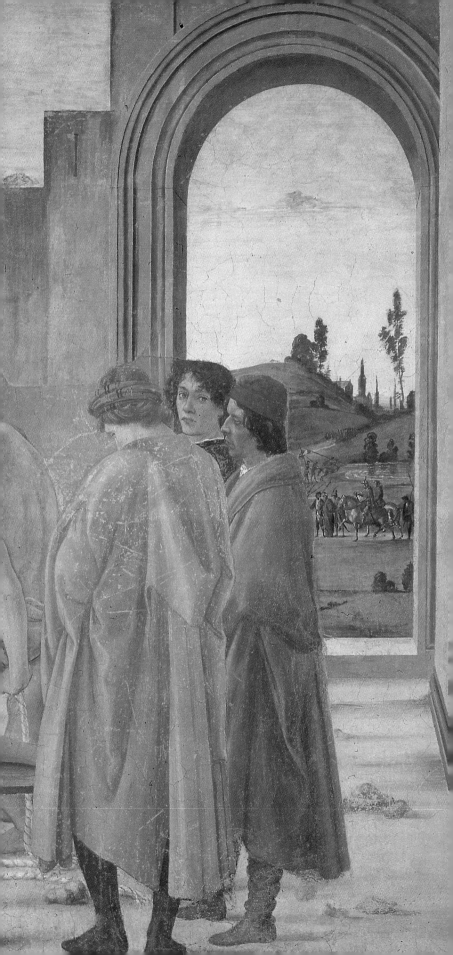

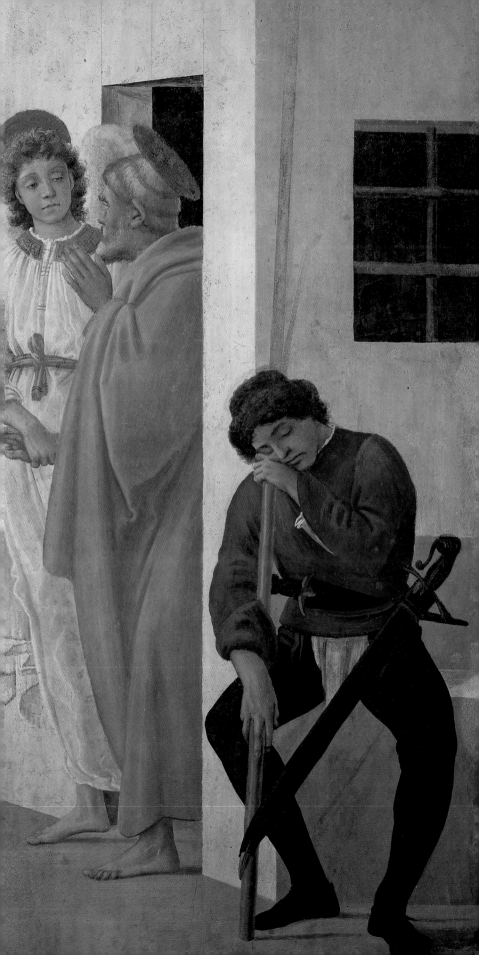

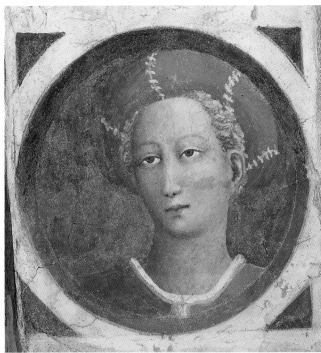

59. *St Peter Freed from Prison (Filippino Lippi)*
230 x 88 cm. Florence, Brancacci Chapel

60,61. *The two medallions discovered behind the altar in the Brancacci Chapel*

men standing between St Peter and Nero is Antonio del Pollaiolo, while the one to the left is probably Raggio, a merchant's broker mentioned by Vasari (Berti, 1957), and not Botticelli as had been suggested

previously; whereas in the group of three to the right in the *Crucifixion of Peter*, the man looking towards the audience is probably Botticelli.

St Peter Freed from Prison

This episode is recounted in the Acts of the Apostles (12: 1-6). The scene shows Peter being awoken by the Angel and taken out of his cell, while the guard is sound asleep and notices nothing.

The fresco was originally attributed, along with all the others, to Masaccio. Gaye (1838) was the first

scholar to attribute it to Filippino and this theory was immediately accepted by the authors of the critical edition of Vasari's Lives published in Florence in 1848, but not by Rosini. In 1864 Cavalcaselle confirmed the attribution to Filippino; all later critics have been in agreement.

The Heads in the Medallions

The two heads that have been discovered in the jambs of the original two-light window behind the altar are, according to Baldini (1984), the work of two artists: the lefthand one is by Masolino, the righthand one by Masaccio, for the former is painted with a clearly marked outline and the latter is modelled directly with the use of light. But there are many scholars who disagree and believe that both heads are by Masolino: Boskovits (1987), Berti (1988), Wakayama (1987) and Bologna (1989).

And the foliage pattern decorations that cover the

jambs also appear to be the work of two different artists: the floral ornamentations above the two heads and the motif that frames the scene at the top, just under the window sill, are to be attributed to Masolino, whereas the decorations below the two medallions are more probably the work of Masaccio. But there is one scene that everyone agrees is by Masaccio: there are only two small fragments left of it, above the altar, but it was originally the scene of the *Crucifixion of Peter*.

The Pisa Polyptych

On February 19th 1426 Masaccio agreed to paint an altarpiece for a chapel in the church of the Carmine in Pisa for the sum of 80 florins, having received the commission from Ser Giuliano di Colino degli Scarsi, notary from San Giusto. On December 26th of that year the work must have been already completed since payment for it is recorded on this date.

Vasari describes the work as follows: "In the church of the Carmine in Pisa on a panel, which is inside a chapel in the transept, is an Our Lady and Child, and at her feet are some angels playing instruments, one of which, playing a lute, is listening attentively to the harmony of the music. Our Lady is between St Peter, St John the Baptist, St Julian and St Nicholas, all alert and lively figures. Underneath in the predella are stories from the lives of the saints, in miniature, and in the centre the three Wise Men paying homage to Christ; in this part are some horses painted wonderfully from life, so that one could not wish for better; and the courtiers of the three kings are dressed in garments in fashion at that time. And on top, to finish off the said panel, there are many paintings of saints around a Crucifixion."

This detailed description related in the second edition of the Lives in 1568 was the basis for art critics for the attempt at reconstruction and for the recovery and identification of the work which was dismantled and dispersed in the 18th century.

Only eleven pieces have so far come to light and they are not sufficient to enable a reliable reconstruction of the whole work. St Peter and St John the Baptist, St Julian and St Nicholas, who were on either side of the central part, are missing; only their recovery could sort out the problem of the structure of the painting. According to some scholars the saints were in pairs, within a single space, while others consider it as a triptych in three sections clearly divided by small pillars or columns according to the standard Gothic practice.

62 The *Madonna and Child Enthroned with Four Angels*, in the National Gallery since 1916, had been recorded in London in the Woodburn Collection in 1855 and then in the Sutton Collection with attribution to Gentile da Fabriano. In 1907 it was seen here by Berenson who recognised it as a work of Masaccio and the central part of the Pisa Polyptych.

63 The *Crucifixion*, since 1901 in the Museo di Capodimonte in Naples, was attributed to Masaccio by Venturi and connected with the Pisa Polyptych.

67-70 *St Augustine, St Jerome, Elijah the Prophet* and *Albert the Patriarch*, once in the Butler Collection in London and attributed to Masaccio, were subsequently bought by the Berlin Museum where they are now. They were connected with the Pisa Polyptych by Schubring 1906 and, with others now lost, are generally thought to have adorned the pilasters which framed the polyptych on each side.

The Berlin Museum bought the panel with the *Crucifixion of St Peter* and the *Beheading of St John the Baptist* in 1880 in Florence, where it was in the Capponi Collection, together with the panel of the *Adoration of the Magi* also in this collection. 64 65

In 1908 the Berlin Museum acquired a third panel with the *Stories of St Julian and St Nicholas* thus gaining possession of the whole recovered predella of the Pisa Polyptych. While the Masaccio attribution is undisputed for the first two panels, the third is considered to be a product of the workshop (lo Scheggia, in Salmi's opinion, or Andrea di Giusto in Berenson's). 66

The *St Paul*, now in the Museo di San Matteo in Pisa, is the only piece left in the city for which it was painted. In the 17th century it was attributed to Masaccio (as can be seen from an inscription on the back of the panel) and all through the 18th century when the painting was still in the Opera della Primaziale, which it left in 1796 to go to the Museo di San Matteo; but some critics still favoured Andrea di Giusto. The subsequent attribution to Masaccio is now generally accepted by all critics. 71

The *St Andrew* went from the Lanckoronski Collection in Vienna to the royal collection of the prince of Liechtenstein in Vaduz, and today is in the Paul Getty Museum, Malibu. 72

These pieces are all that has been rediscovered and is referrable to the Pisa Polyptych up till the present date. A possible addition is a small tondo depicting an *God the Father Blessing* which is now in the London National Gallery. According to Philippi, who noted it in 1919, it could have been at the top of the central panel above the Crucifixion, as sometimes found in contemporary or earlier works. However not everyone agrees on the authorship: this writer too considers it a product of the workshop, without excluding a possible connection with the Pisa Polyptych, in which the workshop participated in the *Stories of St Julian and St Nicholas* in the predella.

62. Madonna and Child Enthroned with Four Angels 135 x 73 cm. London, National Gallery

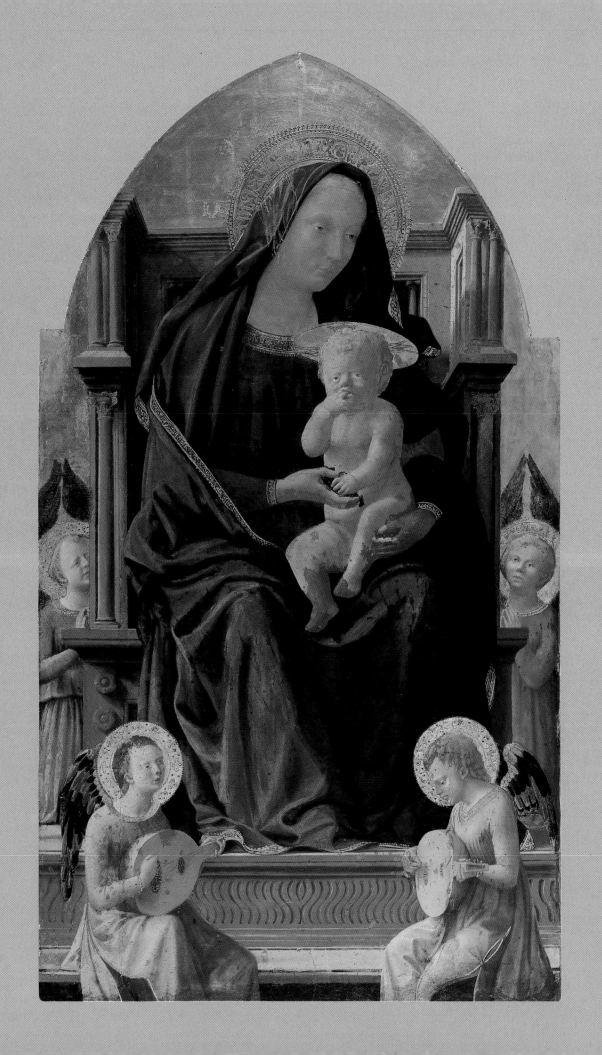

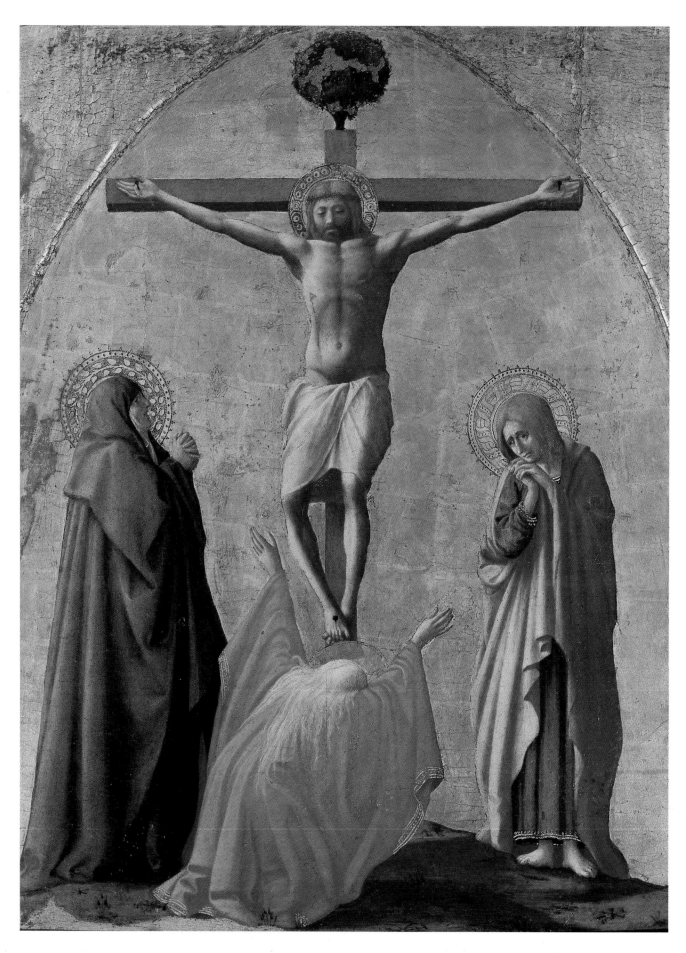

63. Crucifixion
83 x 63 cm. Naples, Museo di Capodimonte

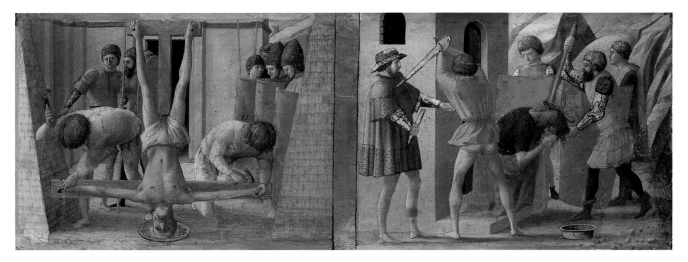

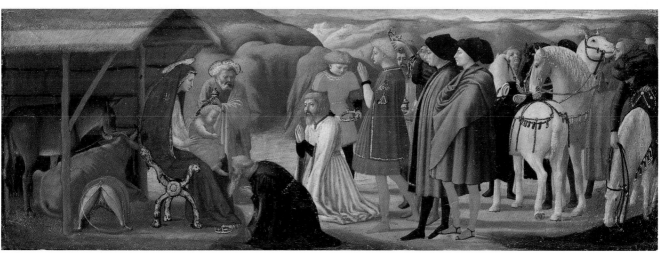

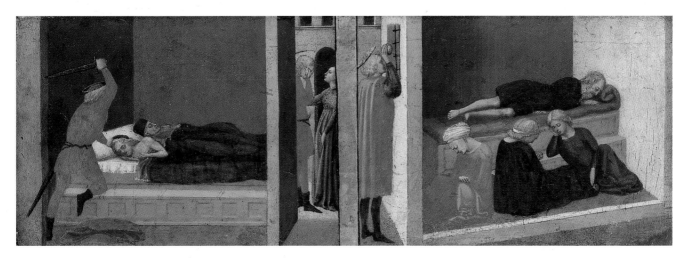

64. Crucifixion of St Peter and Beheading of St John the Baptist
21 x 61 cm
Berlin-Dahlem, Gemäldegalerie

65. Adoration of the Magi
21 x 61 cm
Berlin-Dahlem, Gemäldegalerie

66. Stories of St Julian and St Nicholas
22 x 62 cm
Berlin-Dahlem, Gemäldegalerie

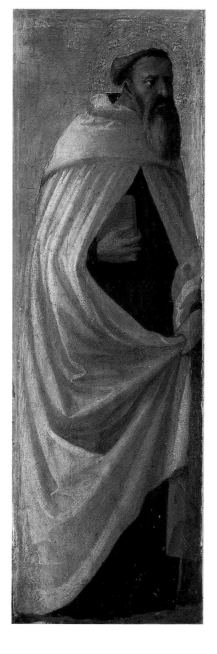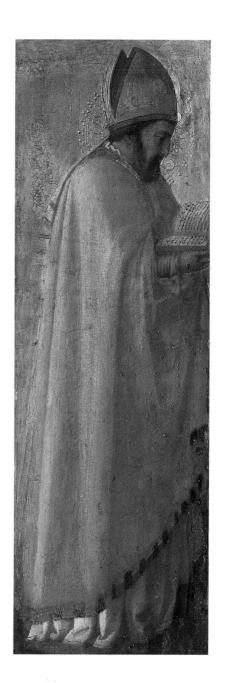

67,68. A Carmelite Monk and St Augustine
38 x 12 cm
Berlin-Dahlem, Gemäldegalerie

The *Madonna of Humility*, now in the Natio-nal Gallery of Washington, is another work attri-buted to Masaccio by Berenson, followed amongst others by Longhi, Salmi, Pope-Hennessy, Shapley and Volpe. In this writer's opinion the work is not by Masaccio but a connection with Andrea di Giusto is apparent; but it is difficult to judge because there are signs of extensive repainting on a wornout base. Brandi considered attri-bution to Paolo Schiavo while Berti now thinks it is probably an early Filippo Lippi: "beginnings in

Masaccio's footsteps" and after the Pisa Polyptych.
The execution of the Pisa Polyptych took place during intervals in the work on the Brancacci Chapel in the church of the Carmine in Florence, and is a splendid testimony of the artist's maturity.
The connection of the polyptych with the Florentine church of the Carmine can be seen in the features of saints Paul and Andrew, who appear in the *Trib-* 28 *ute Money*. Here they appear more introspective and in rapt meditation rather than in action. This portrayal emphasizes the solemn monumentality of the en-

69,70. St Jerome and a Carmelite Monk
38 x 12 cm
Berlin-Dahlem, Gemäldegalerie

throned Madonna. The echoes and the study of ancient and contemporary sculpture, from Nicola Pisano to Donatello, are enhanced in a new idiom of realism in its most penetrating forms in this rendering of the Madonna. The throne in perspective and rendered realistically in relation to the height of the work on the altar (consequently to the position of the observer), is undoubtedly the focal point of the whole composition. It gives each figure its right place in a proportionate space, as in the vision looking up from 63 below of the *Crucifixion* which stood directly over the

central part, and confirmed by the gold monochrome background. This assumes, as critics have pointed out (e.g. Parronchi), a greater significance than Gothic conventionalism, and gives a sense of dazzling atmosphere capable of creating a real space in which the figures appear intensified, although firmly planted on the ground.

Space, the arrangement of figures, objects, animals and buildings — no longer on a gold ground but against horizons of mountains, sky and clouds — lend depth to the land and the foreground as in the *Trib-* 28

71. St Paul
51 x 30 cm. Pisa, Museo di San Matteo

ute *Money* and the other Brancacci Chapel episodes and in the predella stories now in Berlin. Thus the
64 story of the *Martyrdom of St Peter* is clearly associated with a fragment found in the Brancacci Chapel and

thought to be part of a lost Crucifixion of St Peter. In the *Beheading of St John the Baptist* the execu- 64 tioner's body is the same as the tax-gatherer seen from behind in the *Tribute Money*; in the *Adoration* 65

72. St Andrew
51 x 31 cm. Malibu, Paul Getty Museum

of the Magi more than one set of features is common to the stories in the church of the Carmine; and in the other *Stories of St Nicholas and St Julian* (in this last note the figure of the repentant saint which repeats the gesture by Masaccio in the *Expulsion from the Garden of Eden*) even though they are considered to have been executed by the workshop, as mentioned earlier.

66

21

The Agony in the Garden

This small panel in the shape of a small altarpiece is now in the Lindenau Museum in Altenburg and contains two episodes: the *Agony in the Garden* and the *Communion of St Jerome*. The execution is usually fixed at immediately after the Pisa Polyptych.

At the end of the last century they were attributed by Schmarsow to Masaccio, but this opinion did not get much support from later critics, from Berenson, who assigned the work to Andrea di Giusto, up to Longhi and Salmi, who thought it was by Paolo Schiavo. The value of the work was revealed by Oertel in 1961, followed by Berti (1964) and Parronchi (1966) who both opted for Masaccio, seeing in it a forcefully expressed originality.

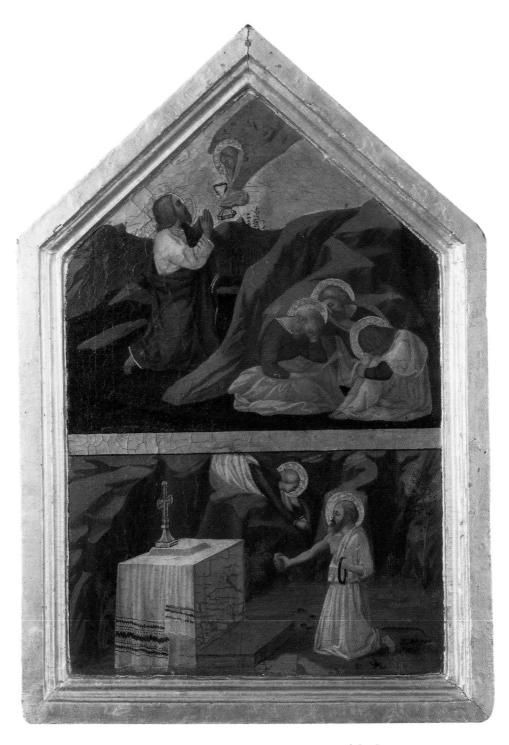

73. Agony in the Garden and Communion of St Jerome
50 x 34 cm. Altenburg, Lindenau Museum

The Madonna and Child

Dating from the same time as the Pisa Polyptych is a small painting on a gold ground, depicting the Madonna holding the Child and stroking him under the chin with her right hand. Her robe of bright blue, bordered with gold and decorated with cubic letters, follows the movement of the figure. The panel is also painted on the back with a coat-of-arms in a shield showing six red stars on a yellow field divided across the middle by a dark band with a golden cross at the centre, the whole surmounted by a cardinal's hat: it was the coat-of-arms of Antonio Casini who was made a cardinal on May 24th 1426.

Longhi, who brought the picture to public notice for the first time in 1950, put it at the time of the Pisa Polyptych, 1426, because of the chromatic harmony and the "wonderful spatial effects." The attribution to Masaccio is accepted by most critics.

From a private collection, it was shown in Rome in 1952 at the "Second National Exhibition of Works of Art Recovered from Germany," then at a similar exhibition in Florence and finally in 1984 at the Palazzo Vecchio with other works recovered by Rodolfo Siviero. It was assigned to Florence by the state in 1988 and is now in the Uffizi.

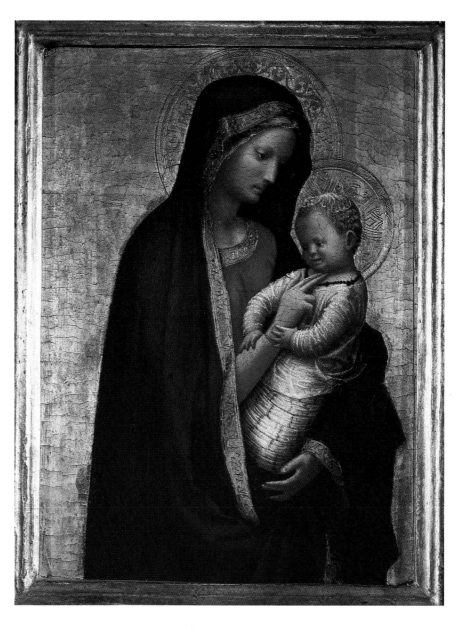

74. Madonna and Child
24 x 18 cm. Florence, Uffizi

The Story of St Julian

The *Story of St Julian*, a small panel thought by some to be connected with the Pisa Polyptych and now in the Museo Horne in Florence, was considered by Ragghianti to be the first draft of the section of the predella on the same subject. Brought to light by Gamba in 1920 and attributed to Masaccio, the work is accepted by all critics as definitely original. The stylistic connection with the Pisa Polyptych is important not only because of the subject (the story of St Julian) but also because of the placing of events in space and the view of landscape to the left, which seems to be a repetition of the rhythmic sequences in a space bordered by distant mountains outlined against a strip of sky (as in the *Adoration of the Magi*). 65

The Trinity

There are various opinions as to when the fresco of the *Trinity* in the church of Santa Maria Novella was painted. Some date it with the early work on the Brancacci Chapel (c. 1425, Borsook, Gilbert, Parronchi), or in a phase half-way through it (c. 1427, Salmi, Procacci; 1426, Brandi), or right afterwards and just before the departure for Rome (c. 1427-28, Berti). It is mentioned in the earliest sources, and was described in detail in the 1568 second edition of the Lives by Vasari, who emphasized the virtuosity of the "trompe l'oeil" in the architectural structure of the painting: "a barrel vault drawn in perspective, and divided into squares with rosettes which diminish and are foreshortened so well, that there seems to be a hole in the wall."

Only two years after Vasari's book was published, the erection of a stone altar caused the fresco to be covered up by a panel of the Madonna of the Rosary painted by Vasari himself. Thus the fresco remained unknown to future generations from 1570 to 1861 when owing to the removal of the 16th-century altar it was again uncovered. After being removed and placed on the internal facade of the church between the left and the central doors, it was put back in its original position in 1952, as a result of Procacci's discovery, beneath the 19th-century neo-Gothic altar,

75. *Story of St Julian*
24 x 43 cm
Florence, Museo Horne

76. *The Trinity*
667 x 317 cm
Florence, Santa Maria Novella

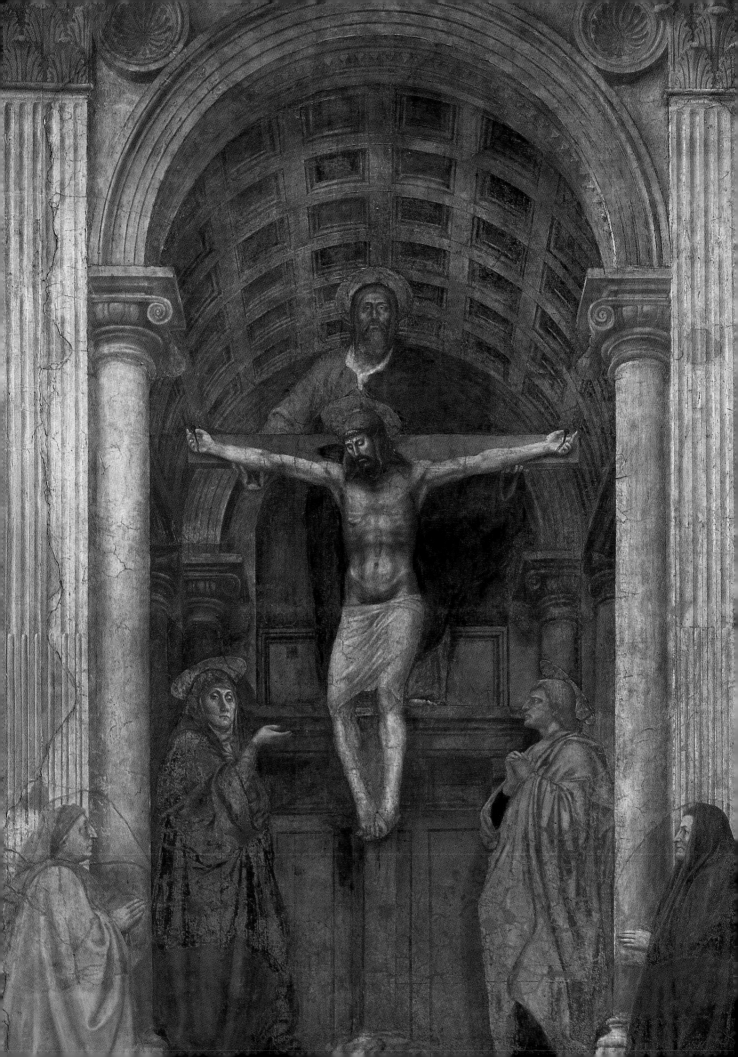

of the lower section of the fresco with Adam's skeleton and the painted altar table, once part of the whole work.

One of the most extraodinary pages in the history of art was thus reconstructed and taken up by critics as the symbol and revelation of Brunelleschi's principles in architecture and the use of perspective, to the point that more than one critic believed Brunelleschi to have had a direct hand in the work. Thus Kern, Frey, Sampaolesi, Gioseffi, Parronchi, Berti and Rossi are against Mesnil, Pertel, Pittaluga, Salmi, Baldini, Cristiani Testi, Del Bravo, and Procacci who maintain instead that the work is entirely by Masaccio, here interpreting the rule laid down by Brunelleschi.

When the fresco was painted, the wall received daylight from two sources: one was the round window in the facade; the other, now no longer existing because blocked up, was the entry to the church from Via degli Avelli. These sources of light, which are also points of access for the visitor, are the basis on which Masaccio makes use of light effects and perspective.

As Carlo del Bravo realized (1978), the protagonists of the scene and the scene itself were meant to appear, not as narrative picture but interpreted in the sense that "the central figures, rather than representing sacred characters, are themselves solid images, polychrome statues in a niche, with whom the sculptural forms of the donors are in a spatial, rather than a narrative, context." In view of this unity of presence, reflecting Brunelleschi in one sense and Alberti in another, the entire work may be confidently attributed to Masaccio. A "ficta et picta" chapel for the painting of which every technical device of graphics and lighting which could create an illusion of reality was made use of. It was in accordance with the canons of Alberti — as recently observed by Mallé, Borsook and now Berti — the use of the technical procedures of the squared film, codified in the De Pictura shortly afterwards (1436).

Apart from doubts as when the work was executed, it is uncertain who commissioned it: some think it was Fra Lorenzo Cardoni, prior in Santa Maria Novella from 1423 to early 1426, or Domenico Lenzi (who died in 1426 and is buried right next to the fresco). Another possibility is Alessio Strozzi, who was Cardoni's successor in Santa Maria Novella and the friend and counsellor of Ghiberti and Brunelleschi.

The most likely interpretation of the Trinity — as Rossella Foggi recently observed (1989) — is that the painting alludes to the traditional medieval double chapel of Golgotha, with Adam's tomb in the lower part (the skeleton) and the Crucifixion in the upper part (Tolnay, 1958; Schlegel, 1963). But it can also assume the significance of the journey the human spirit must undertake to reach salvation, rising from this earthly life (the corruptible body) through prayer (the two petitioners) and the intercession of the Virgin and saints (John the Evangelist) to the Trinity (Simson, 1966).

A close-up view of the skeleton in the sarcophagus also revealed the ancient warning, in clear letters: I WAS WHAT YOU ARE AND WHAT I AM YOU SHALL BE. The sarcophagus was underneath the altar-table which was also "ficta et picta"; only later a real and perhaps portable table must have been attached to it, in order to be able to officiate at it. The Wooden Cross by Maso di Bartolommeo now in the Sacristy was part of this altar.

Associations with real buildings have been noted by critics: taken from Brunelleschi in the Barbadori Chapel (Salmi) or from Donatello (the Merchants' Tabernacle in Orsanmichele), but also inspired by Masaccio, as in the Cardini Chapel of Buggiano, and in the church of San Francesco in Pescia.

77. The Trinity, detail
Florence, Santa Maria Novella

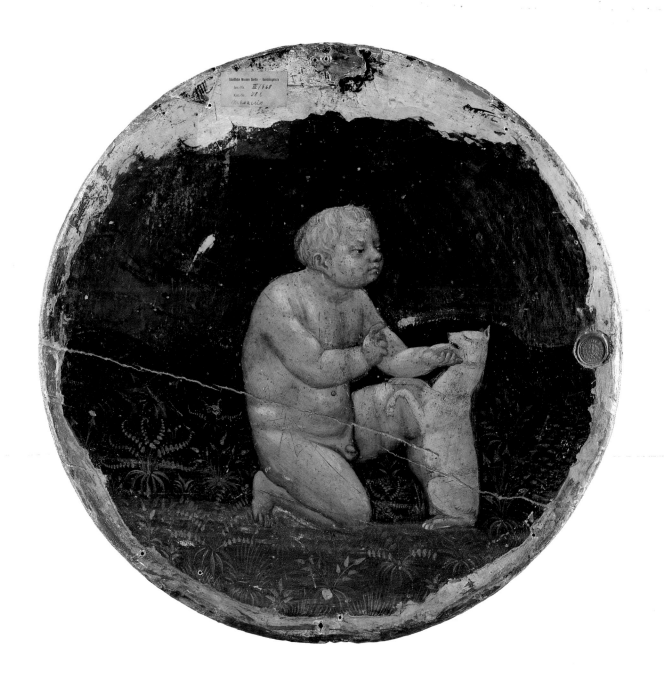

The Berlin Tondo

This *round plate*, with a Nativity on the front and a putto and a small dog on the back, was in San Giovanni Valdarno in 1834 in the possession of Sebastiano Ciampi, and has been in the Berlin Museum since 1883, having come from Florence. It dates from Masaccio's last period in Florence, before he went to Rome.

It was attributed to Masaccio (Guerrandi Dragomanni in 1834, seconded by Müntz, Bode, Venturi, Schubring, Salmi, Longhi and Berenson) but others preferred Andrea di Giusto (Morelli) or Domenico di Bartolo (Brandi) or an anonymous Florentine between 1430 and 1440 (Pittaluga,

Procacci, Meiss). Baldini, Berti, Parronchi and Ragghianti considered it to be by Masaccio. It was defined as the "first Renaissance tondo" by Berti, who with the others drew attention to the important innovations and the correct architectural perspective reflecting a greater knowledge and affirmation of the classicism of Brunelleschi. Here the Florentine idiom is evident in the colour sequences of the geometrical patterns on the walls of the building and in the court. This is in perfect classical harmony, and was to appear again in the stories of Fra Angelico and the architecture of Michelozzo in San Marco.

80

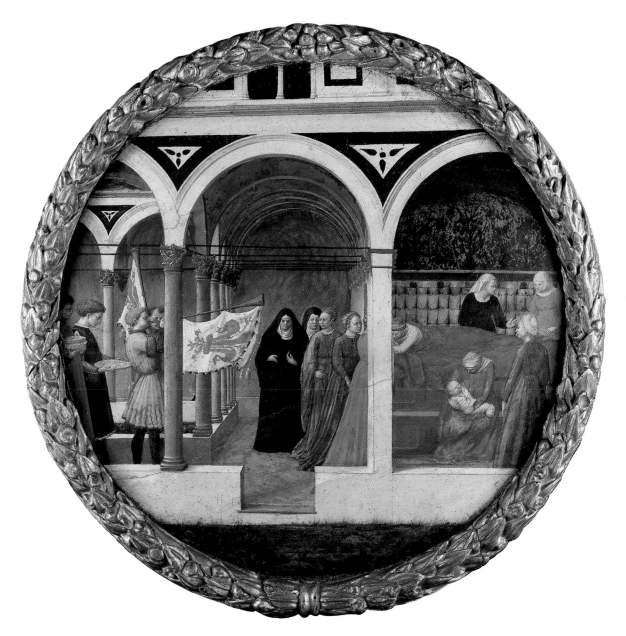

78,79. Plate of Nativity, putto and a
small dog
diam. 56 cm
Berlin-Dahlem, Gemäldegalerie

80. Michelozzo, Library of San Marco in
Florence

The Santa Maria Maggiore Polyptych

In 1428 Masaccio left Florence for Rome to work on the polyptych in Santa Maria Maggiore, interrupting for good the work on the Brancacci Chapel, but he only had time to begin the left hand side with the panel of *St Jerome and St John the Baptist* (now in London) before he died aged only 27.

Once again Masaccio and Masolino worked together, but this time Masolino had to finish the job alone. According to Vasari, Masaccio had acquired "great fame" in Rome, enough to be commissioned to paint a fresco for the cardinal of San Clemente, in the chapel with the stories of St Catherine. However some scholars (Venturi, Longhi and Berti with reservations) consider that Masaccio probably only had a hand in the sinopia of the *Crucifixion*, in the knights on the left.

The *Santa Maria Maggiore Polyptych* is no longer in its original place. The panels making up the front side were separated from the back ones, like those of the Duccio Maestà in Siena Cathedral. Although in the 17th century the six major panels were still in Rome in Palazzo Farnese, in the 18th century they were dispersed again for good.

According to a reconstruction of Clark based on the existing and recognised pieces, the central part of the triptych must have represented the episode of the *Foundation of the church of Santa Maria Maggiore*, with *St Jerome and St John the Baptist* on the left side and *St John the Evangelist and St Martin of Loreto* on the right. On the other side the *Assumption* was in the centre with *St Peter and St Paul* on the left and *St Liberio and St Matthias* on the right. The whole work was perhaps completed by three cuspidated elements and a predella. Of these, scholars believe that some components are recognisable: the *Crucifixion* in the Vatican Pinacoteca which was one of the central cusps, the *Burial of the Virgin* also in the Vatican and part of the predella and a *Marriage of the Virgin* once in the Artand de Montor Collection but lost during the last war.

The six major panels of the triptych are now scattered in various museums as follows: *St Jerome and St John the Baptist* and *St Liberio and St Matthias* in the London National Gallery; the *Foundation of Santa Maria Maggiore* and the *Assumption* in the Capodimonte Museum in Naples; *St Peter and St Paul* and *St John the Evangelist and St Martin of Loreto* in the Johnson Collection in Philadelphia. All these works are by Masolino, excluding the left hand panel with *St Jerome and St John the Baptist* which is by Masaccio. This attribution was made by Clark in 1951 and has been generally accepted by all critics, but a few scholars assigned it to Masolino or even Domenico Veneziano, dating it as late as the 1430's.

Dating varies from as early as 1422-23, on the occasion of the Holy Year of 1423 (Parronchi, Hartt) and coinciding with a first trip to Rome, to 1425-26 (Clark, Longhi, Bologna) and to 1428 (Salmi, Brandi, Procacci, Baldini, Mancinelli and Meiss, who had previously agreed on an earlier date). This last date would better explain his participation in this panel only. It would also fit in more satisfactorily with the style of the whole work which "constitutes a mature achievement of the collaboration between Masolino and Masaccio," since Masaccio's influence is distinctly noticeable even in the minor parts of the painting, such as the predella panel with the *Burial of the Virgin*. Whatever the event, this exceptional panel now in London is the only certain record left to us of Masaccio's activity in Rome. Attempts by critics to detect Masaccio's hand in the frescoes of the Chapel of Santa Caterina in San Clemente are still only a conjecture. Since the work in question, the *Crucifixion*, is badly damaged and the remaining traces are difficult to judge by, no definite conclusion can be reached.

Masaccio died in Rome. When the news of his death reached Florence, it made a great impression. Vasari reports that Filippo Brunelleschi "hearing of his death" said: "This is a very great loss for us."

81. St Jerome and St John the Baptist
114 x 55 cm
London, National Gallery

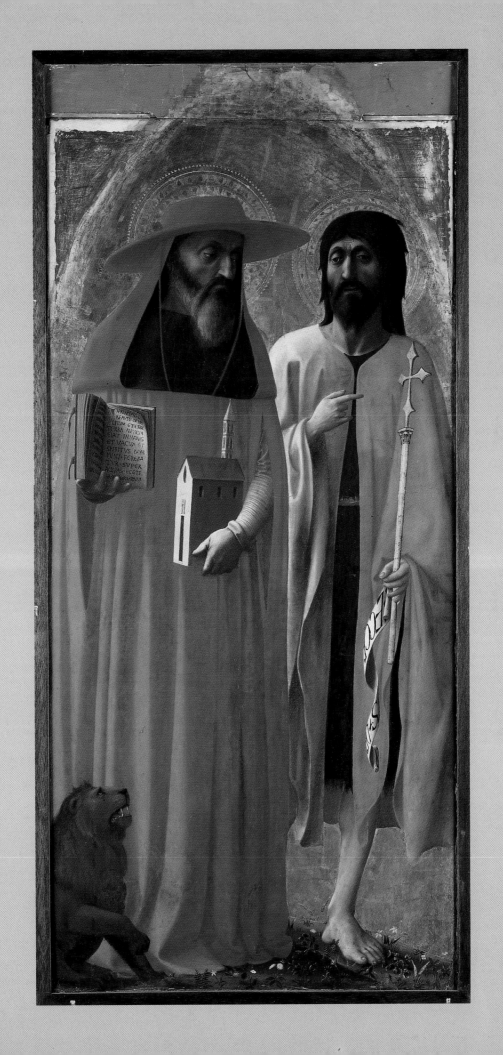

Bibliography

O.H. GIGLIOLI, *Masaccio*, in "Bollettino del R. Istituto di Arch. e Storia dell'Arte", III, 1929, pp. 55-101

H. LINDBERG, *To the Problem of Masolino and Masaccio*, Stockholm 1931

U. PROCACCI, *Documenti e ricerche sopra Masaccio e la sua famiglia*, in "Rivista d'arte", 1932, pp. 489-503

M. SALMI, *Masaccio*, Rome 1932

R. OERTEL, *Masaccio und die Geschichte der Freskotechnik*, in "Jahrbuch der Preussischen Kunstsammlungen", LV, 1934, pp. 229-240

P. TOESCA, *Masaccio*, in "Enciclopedia Italiana", XXII, 1934

M. PITTALUGA, *Masaccio*, Florence 1935

U. PROCACCI, *Documenti e ricerche sopra Masaccio e la sua famiglia*, in "Rivista d'Arte", 1935, pp. 91 ff.

M. MEISS, *The Madonna of Humility*, in "Art Bulletin", XVIII, 1936, p. 435

R. LONGHI, *Fatti di Masolino e di Masaccio*, in "Critica d'Arte", 1940, pp. 145-191

M. SALMI, *Masaccio*, Milan 1948 (2nd edit.)

R. LONGHI, *Recupero di un Masaccio*, in "Paragone", 5, 1950, pp.3-5

K. CLARK, *An Early Quattrocento Triptych from Santa Maria Maggiore, Roma*, in "Burlington Magazine", 1951 pp. 339-347

U. PROCACCI, *Masaccio*, Milan 1951 (2nd edit. 1952)

R. LONGHI, *Presenza di Masaccio nel trittico della Neve*, in "Paragone", 25, 1952, pp. 8-16

M. SALMI, *Masaccio* in "Enciclopedia Cattolica", Vatican City, VIII, 1952, pp. 266-271

U. PROCACCI, *Sulla cronologia delle opere di Masaccio e di Masolino tra il 1425 e il 1428*, in "Rivista d'Arte", 1953, pp. 3-55

E. BORSOOK, *The Mural Painters of Tuscany*, London 1960

L. BERTI, *Masaccio 1422*, in "Commentari", 1961, pp. 84-107

P. MELLER, *La Cappella Brancacci. Problemi ritrattistici e iconografici*, in "Acropoli", III, 1961, pp. 186 ff. and IV, pp. 273 ff.

U. BALDINI, *Masaccio*, in "Enciclopedia Universale dell'Arte", Rome 1962, pp. 866-77

M. MEISS, *Masaccio and the Early Renaissance: The circular plan*, in "Studies in Western Art", Princeton, II, 1963, pp. 123-145

U. SCHLEGEL, *Observations on Masaccio's Trinity Fresco in Santa Maria Novella*, in "Art Bulletin", March 1963, pp. 19-33

L. BERTI, *Masaccio*, Milan 1964

F. BOLOGNA, *Gli affreschi della Cappella Brancacci*, Milan 1965

U. PROCACCI, *Masaccio e la Cappella Brancacci*, Florence 1965

F. BOLOGNA, *Masaccio*, Milan 1966

A. PARRONCHI, *Masaccio*, Florence 1966

L. BERTI, *L'opera completa di Masaccio*, Milan 1968

C. DEL BRAVO, *Masaccio. Tutte le opere*, Florence 1969

R. FREMANTLE, *Masaccio e l'antico*, in "Critica d'Arte", CIII, 1969, pp. 39-56

J. POLZER, *The anatomy of Masaccio's Holy Trinity*, in "Jahrbuch der Berliner Museen, XIII, 1971, pp. 18-59

G. PREVITALI, *Masaccio*, in "Encyclopedia Universalis", Paris 1971, p. 252

U. PROCACCI, *Nuove testimonianze su Masaccio*, in "Commentari", 27, 1976, pp. 223-237

A. MOLHO, *The Brancacci Chapel: studies in its iconography and history*, in "Journal of the Warburg and Courtauld Institutes", 40, 1977, pp. 50-98

J.H. BECK, *Masaccio: the documents*, in "The Harvard University Center for Italian Renaissance Studies", Villa I Tatti, Locust Valley-New York 1978

EIKO M. L. WAKAYAMA, *Lettura iconografica degli affreschi della Cappella Brancacci: analisi dei gesti e della composizione*, in "Commentari", 1-4, 1978, pp.72-80

B. COLE, *Masaccio and the Art of Early Renaissance Florence*, Bloomington & London, 1980

U. PROCACCI, *Masaccio*, Florence 1980

U. BALDINI, *Nuovi affreschi nella Cappella Brancacci. Masaccio e Masolino*, in "Critica d'Arte", I, 1984, pp. 65-72

U. PROCACCI, U. BALDINI, *La Cappella Brancacci nella Chiesa del Carmine a Firenze*, in "Quaderni del Restauro", Olivetti 1, Milan 1984

O. CASAZZA, *Il ciclo delle storie di San Pietro e la "Historia Salutis". Nuova lettura della Cappella Brancacci*, in "Critica d'Arte", IX, 1986, pp. 69-84

O. CASAZZA, *Settecento nella Cappella Brancacci*, in "Critica d'Arte", 11, 1986 pp. 68-72

U. BALDINI, *Restauro della Cappella Brancacci, primi risultati*, in "Critica d'Arte", IX, 1986, pp. 65-68

L. PANDIMIGLIO, *Felice di Michele vir clarissimus e*

una consorteria: i Brancacci di Firenze, in "I Quaderni del Restauro" (Olivetti), 1987

U. BALDINI, "Le figure di Adamo ed Eva formate affatto ignude in una cappella di una principale chiesa di Fiorenza", in "Critica d'Arte", LIII, n. 16, 1988, pp. 72-77

O. CASAZZA, La grande gabbia architettonica di Masaccio, in "Critica d'Arte", LIII, n. 16, 1988, pp. 78-97

U. BALDINI, Del "Tributo" e altro di Masaccio, in "Critica d'Arte", LIV, n. 20, 1989, pp. 29-38

P.A. ROSSI, Lettura del "Tributo" di Masaccio, in "Critica d'Arte", LIV, n. 20, 1989, pp. 39-42

L. BERTI, R. FOGGI, Masaccio, Florence 1989

O. CASAZZA, P. CASSINALLI LAZZERI, La Cappella Brancacci. Conservazione e restauro nei documenti della grafica antica, Modena 1989

82. Story of St Nicholas
Berlin-Dahlem, Gemäldegalerie

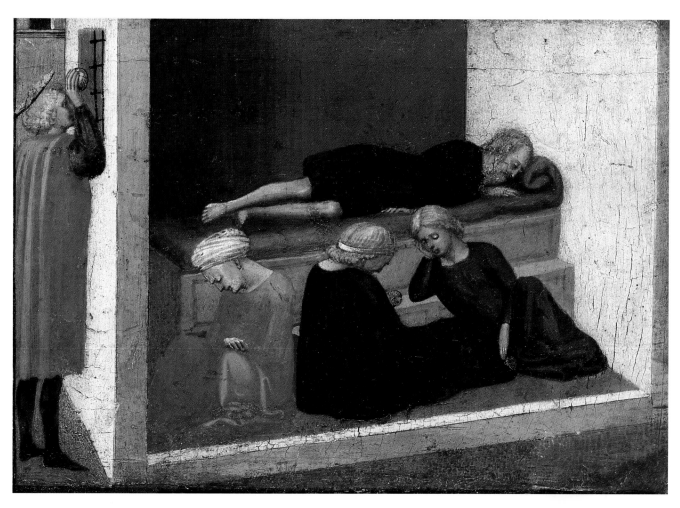

Index of Illustrations

Adoration of the Magi (Berlin), 1,65
Agony in the Garden and the Communion of St Jerome (Altenburg), 73
Battle of San Romano (Paolo Uccello), 17
Plate of Nativity (Berlin) 78,79

Brancacci Chapel:

Baptism of the Neophytes, 35,36
Crucifixion of St Peter, 56-58
Disputation with Simon Magus, 54
Distribution of Alms and Death of Ananias, 52,53
Expulsion from the Garden of Eden, 21,26,27
Heads in the Medallions, 60,61
Healing of the Cripple, 18,37-39
Temptation, 40-43
Raising of Tabitha, 37
Raising of the Son of Theophilus, 46
Stories of St Peter, 10,11,
St Paul Visits St Peter in Prison, 44,45
St Peter Freed from Prison, 59
St Peter Healing the Sick with his Shadow, 14,15,50
St Peter Enthroned, 47-49
St Peter Preaching, 34
Tribute Money, 12,13,16,19,28-33

Carmelite monk (Berlin), 67,70
Crucifix (Donatello), 25
Crucifixion (Naples), 63
Crucifixion of St Peter and Beheading of St John the Baptist, 64
Drawing of the Sagra, 7
Library of San Marco (Michelozzo), 80
Madonna and Child (Florence), 74
Madonna and Child Enthroned with Four Angels (London), 62
Madonna and Child with St Anne (Florence), 9
Marsyas, 24
Medici Venus, 22
Palazzo Antinori, 51
Portrait of a Young Man (Boston), 8
Predella of St George (Donatello), 20
Pulpit (Giovanni Pisano), 23
San Giovenale Triptych (Reggello-Florence), 2-5
St Andrew (Malibu), 72
St Augustine (Berlin), 68
St Jerome (Berlin), 69
St Jerome and St John the Baptist (London), 81
St Louis (Donatello), 6
St Paul (Pisa), 71
Stories of St Julian and St Nicholas (Berlin), 66, 82
Story of St Julian, 75
Trinity (Florence), 76,77